IMAGES
of America

MONTVILLE
TOWNSHIP
CELEBRATING
150 YEARS

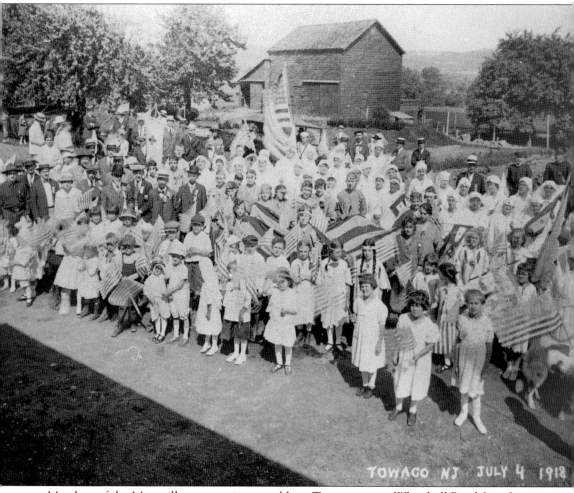

Members of the Montville community assemble at Towaco, across Whitehall Road from Lester Jacobus's store at Pine Brook Road, for a special celebration of the Fourth of July in 1918. (Montville Historical Society.)

On the cover: Pictured are workers at Morris Canal at Bridge No. 97 at Pine Brook Road in Towaco, at the former Van Ness coal and lumberyard. (Montville Historical Society.)

IMAGES
of America

MONTVILLE
TOWNSHIP
CELEBRATING
150 YEARS

Patricia Florio
for Montville Township

ARCADIA
PUBLISHING

Published by Arcadia Publishing
Charleston, South Carolina

Printed in the United States of America

Library of Congress Catalog Card Number: 2017932979

For all general information contact Arcadia Publishing at:
Telephone 843-853-2070
Fax 843-853-0044
E-mail sales@arcadiapublishing.com
For customer service and orders:
Toll-Free 1-888-313-2665

Visit us on the Internet at www.arcadiapublishing.com

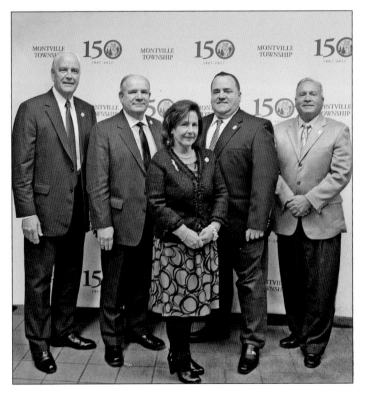

The celebratory kickoff for Montville Township's sesquicentennial year took place on Sunday, January 1, 2017. The Township Committee held its Reorganization Meeting at 3:00 p.m. in the refurbished council chambers at town hall. Afterward, the public was invited to a cocktail reception at the Lake Valhalla Club. In this photograph are Township Committee members at the Reorganization Meeting: Richard D. Conklin, James Sandham Jr. (mayor), Deborah Nielson, Frank W. Cooney (deputy mayor), and Richard Cook. This edition is dedicated to the people of Montville Township.

CONTENTS

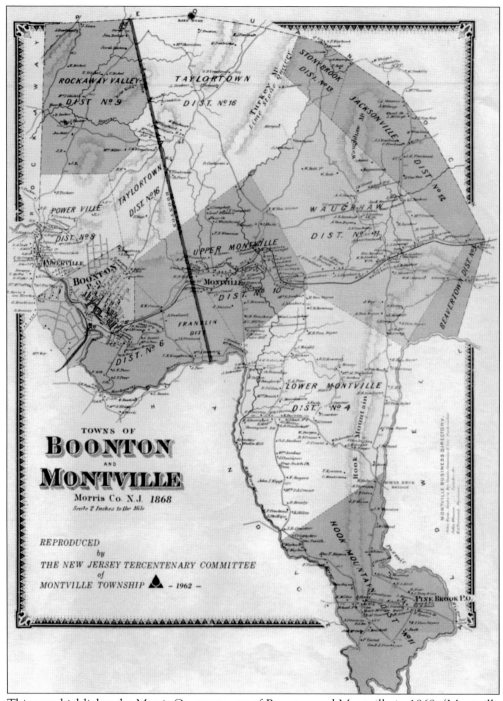

This map highlights the Morris County towns of Boonton and Montville in 1868. (Montville Historical Society.)

INTRODUCTION

Set within a 9-mile-long stretch bounded by the Rockaway River to the west and by the Passaic River to the east, Montville encompasses hills, valleys, and extensive farmland regions. The township of Montville includes the sections of Montville, Towaco (first called White Hall), and Pine Brook. As is true in many of New Jersey's oldest communities, rivers and streams provided navigation routes for the early settlers, prior to the advent of passable roads. Montville is such a place, where its earliest European settlers used logs and native brown fieldstone to craft their homes and used the local resources, such as water, wood, and stone, and a plentiful supply of hides to engage in hunting and tanning occupations. Montville was first known as Uyle-Kill, or "Owl Stream" in Dutch. Prior to the arrival of the Europeans, the wooded terrain was inhabited by the Lenni Lenape tribe, attested to by much evidence of their culture uncovered in the area. The records of the proprietors of East Jersey indicate that settlers of Dutch descent from Bergen County, New York City, and the Hudson River settlements of Hudson, Kingston, and Albany first settled in the Pequannock territory in the late 17th century. The Waughaw Valley in northern Montville is thought to be a Native American name also appearing as Ta Waghaw on old maps. Uyle-Kill was renamed Montville after an area in Connecticut that was the former home of the newly arrived settlers to the area. Montville Township came into being in 1867, after separating from Pequannock Township. The first road was laid out in Montville in 1745, the year that the first gristmill was built. Silas Cook built his cider mill and distillery in the 1790s, a period when a bark mill and tannery existed.

The road now known as Route 202, linking Morristown to the Hudson River, was traversed by Gen. George Washington and his troops to evade the British troops' movements. Washington's soldiers were known to bivouac in Montville, and the general boarded at the Doremus house in what was then White Hall. In the years following the end of the Revolutionary War, Montville grew slowly as a farming community. The self-reliant ways of the individuals who depended on the land and their own abilities sustained Montville's farm culture throughout succeeding generations. The construction of the Morris Canal, conceived to unite the greater region, facilitating the link between commercial interests and distant markets, was begun in 1825, with navigation reaching Montville in 1828. Using the plentiful water, an ingenious system of dams and locks and Scotch turbine-driven incline planes was used to overcome changes in grade of hundreds of feet. Three incline planes were built in Montville, more than in any other community along the canal. The time of peak prosperity for the Morris Canal and Banking Company's enterprise was the late 1860s. Area maps indicate centers of commercial activity

clustered around the canal route from this era. The mill and dye works of John Capstick & Sons brought additional industry and an influx of another wave of workers of European descent to Montville. From its advent in 1883 until it was destroyed by fire in 1913, the mill had a large impact upon the community. The remaining buildings now form one of New Jersey's few surviving late-19th-century industrial complexes: the Capstick Mills Historic District. The coming of the Delaware, Lackawanna, & Western Railroad to White Hall in 1870 offered more rapid and economical transport for goods and materials, compared with the canal. By 1921, the State of New Jersey set out to dismantle the canal, which had long been commercially unsound. The incline planes and canals were removed, drained, and filled, but in Montville, canal heritage is very much apparent in the many historical markers found along roads that skirt the route of the canal and in buildings that date to this important era.

The following books and publications are recommended for readers who wish to pursue further research on historic Montville and the Morris Canal: *History of Morris County 1739–1882*, W.W. Munsell, 1882; *Morris County Historic Sites Survey: Montville*, Morris County Heritage Commission, 1987; *Splinters from the Past: Discovering History in Old Houses*, Alex D. Fowler, 1874; *Historic American Buildings Survey of New Jersey*, William B. Barrett, ed., 1977; and three published walking/driving tours of Montville, available at the museum; *The Morris Canal, Across New Jersey by Water and Rail*, Robert R. Goller, 1999; and *The Morris Canal in Pictures*, James Lee, 1973. The Canal Society of New Jersey, P.O. Box 737, Morristown, New Jersey, 07963, maintains the Canal Museum at Waterloo and features ongoing educational programs.

The Township of Montville will officially celebrate its 150th anniversary on April 11, 2017, and, as part of the celebration, has printed a complete update to the local history book first printed in 2000. The updated book includes a snapshot of the community today and highlights the many changes in the town in nearly two decades. The new book is a highlight of the 2017 Sesquicentennial Celebration.

The new photographs in this book have been provided by municipal staff, including June Hercek (assistant township administrator), and Giancarlo Bruno (planning aide). The photograph of the 150th cake was provided by K.J. Bence Photography in Towaco. The township's 150th logo was designed by Rienzi & Rienzi Communications located in Montville.

The township would like to specifically recognize June Hercek, assistant township administrator, for the long hours of research and work that went into putting together Chapter 7, Montville: Progress of 150 Years. In addition, special thanks to the Township Committee for making this special edition possible.

Also special thanks to our sponsoring donors in grateful appreciation of their generosity in financing this history:

BRONZE LEVEL
O'Dowd family
O'Dowd's Dairy
O'Dowd Associates "With you Since the Beginning"

SILVER LEVEL
Lakeland Bank
Marotta Controls, Inc.
Rockline Industries

While Montville Township has changed from its original incorporation, it still maintains its rural bucolic character, which has made it consistently recognized as one of the 50 best places to live.

One

PORTRAITS OF
MONTVILLE PEOPLE

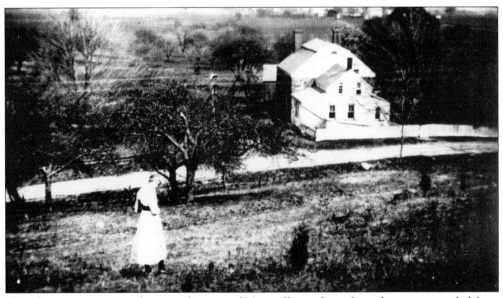

This chapter presents a selection of images of Montville residents from the past, compiled from the Montville Historical Society's collection and contributions from many individuals' family photographic collections. The photographs include a wide range of genre, from daguerreotypes, an early form of photographic portraiture dating from the 1870s, to formal studio portraits and informal snapshots. The portraits are arranged alphabetically. In this informal photograph from the early 1900s, Mabel Van Duyne Hapward is seen on the crest of a hill overlooking Hook Mountain Road. The gambrel-roofed home, to the right, was cleared when Route 80 was built through the area. (Montville Historical Society.)

Isaac and Sarah Bader, both of whom emigrated from Eastern Europe and married in this country, were photographed *c.* 1934. Isaac's mother, Bella Goldie Bader, first came to Montville in 1907, leasing and then purchasing farm property in 1912. The Baders began by growing strawberries and later expanded to other produce. Isaac Bader married Sarah after his first wife—the mother of Barnie, Beckie, and Dave Bader—died during the influenza epidemic. Six children were born to Isaac and Sarah Bader: Annie, Estelle, Ida, Paula, Samuel, and Maris Bader. In earlier days, Sarah Bader was renowned for her substantial home-cooked meals, which featured fresh-picked produce and were offered to the public for $1 on Friday nights. (Courtesy of the Bader family.)

Samuel Bader, a son of Isaac and Sarah Bader, was photographed in the 1940s with his wife, Frances. In 1955, Frances Bader instituted a roadside farm stand, the beginning of the farm's retail merchandising. Today, Bader Farms is a year-round, family-run operation, cultivating more than 60 acres in Montville and Boonton and maintaining greenhouses for nursery stock as well. (Courtesy of the Bader family.)

Henry Beach, postmaster of Montville, was born in New York City in 1800 to Daniel and Abbie Beach, of Scottish descent. After his school years, he managed the New Orleans branch of the business of Mr. Updyke and Mr. Toulain for 16 years. In 1838, he married Maria Louisa Gaines (1817–1898) and lived at the homestead farm in Montville. Beach continued farming, though between 1852 and 1854 he went to California to mine on the Pacific slope. He built the residence for his family and made other improvements to the property at 129 Changebridge Road, Montville. The Beaches had eight children: daughters Adelaide, Antoinette, Isabella, Ewen, Julia Ely, and Laura Augusta, and sons George and Edwin Ely. Known for his honesty and integrity, Beach passed away in 1865. (Montville Historical Society.)

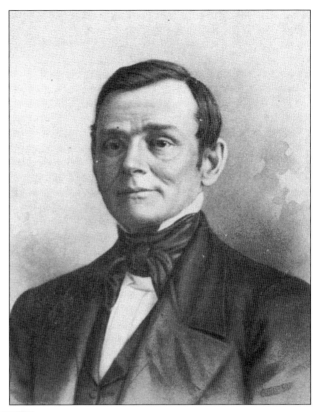

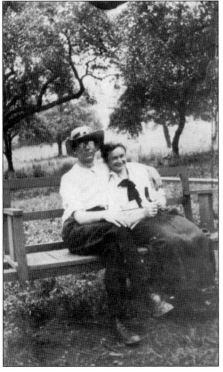

Al Chapin and Sadie Collerd, who later became husband and wife, appear on a courting swing suspended from a sturdy tree bough. The setting of this summer scene was an orchard on the Pine Brook Road farm owned by the Collerds. The Chapin farm was also located in the Pine Brook section. (Courtesy of Betsy D. Demarest.)

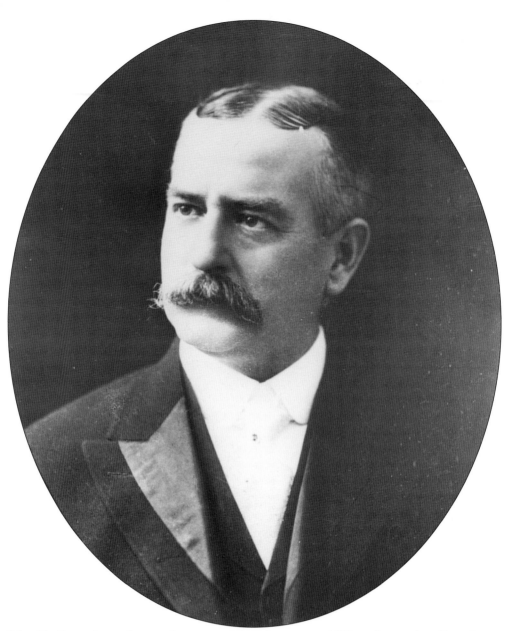

John H. Capstick was born in Lawrence, Massachusetts, in 1856, and moved to Providence, Rhode Island, in 1868. His father, John Capstick, was born in England and moved to Montville with his wife, daughter, and sons in 1883 to set up John Capstick & Sons dye works. His training was as a chemist and colorist for his father's textile business, which he joined at age 27. Upon his father's death, Capstick became president of the company. The dye works was highly successful, extending the family's wealth and influence. After a tragic fire that destroyed the business, Capstick became involved in civic affairs, serving as president of the New Jersey Board of Health for six years and on the state sewerage commission for two years. He also was a director and vice president of the Morristown Trust Company and president of the Boonton National Bank. Capstick was elected to the House of Representatives in 1914 and served until 1916, with illness impeding his service. He passed away in 1918. (Montville Historical Society.)

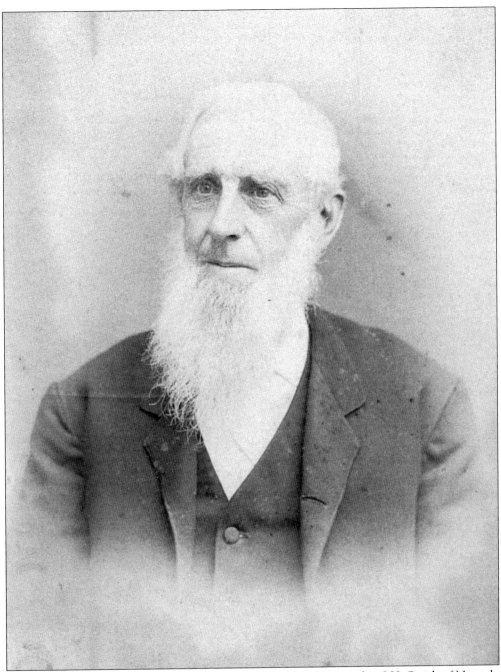

This formal studio portrait of Peter I. Cook was taken by photographer J.H. Smith of Newark. Cook was born in nearby Beavertown (now Lincoln Park) and worked as a tailor until becoming employed by the Morris Canal and Banking Company. After 20 years with that company, he worked as a carpenter until his death in 1889. He and his wife were the parents of ten children. (Courtesy of Lorraine Cook.)

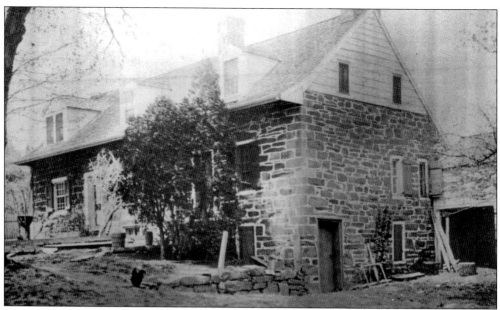

The Simon Van Duyne house at 58 Maple Avenue, in the Pine Brook section, dates from pre-1750, with an addition *c.* 1787. It has remained in the same family for seven generations and was built upon part of William Penn's Mountain Tract. It has been recorded by the Historic American Buildings Survey and is one of the eight Dutch stone farmhouses included in the State and National Registers of Historic Places. (Courtesy of Betsy D. Demarest.)

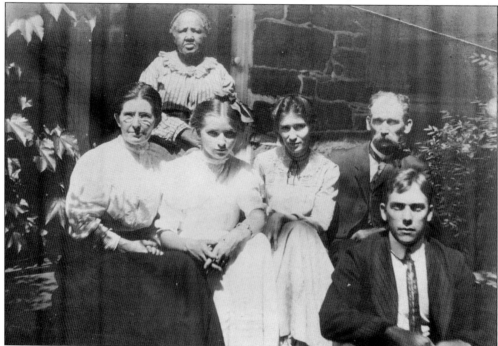

This *c.* 1914 portrait was taken outside the Simon Van Duyne house (see above photograph). Shown from left to right are Augusta Collerd, Mary Wright, Marion Collerd, Bessie Collerd, John Collerd, and an unidentified friend. (Courtesy of Betsy D. Demarest.)

Marion Collerd, mother of Betsy Demarest, is seen in a horse cart in front of her family's farmhouse in this summer scene. A vegetable garden can be seen at the side of the house. (Courtesy of Betsy D. Demarest.)

This undated photograph shows a grouping of family and friends. Shown are, from left to right, the following: (first row) Harry Collerd and Jim Lish; (second row) John Collerd, Mrs. Young, Mrs. Issac Van Ness, Mrs. Rogers, and Matilda Collerd; (third row) Wilfred Collerd and Marion Collerd; (fourth row) Mr. Young, Issac Van Ness, Adna Collerd, Sadie Collerd, Betsy Collerd, Augusta Collerd, and Mr. Potter. (Courtesy of Betsy D. Demarest.)

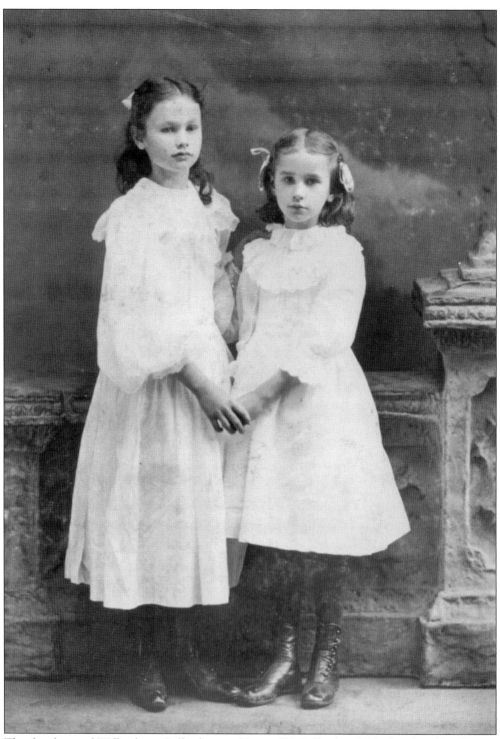

The daughters of Wilberforce Collerd, son of James W. Collerd and Martha Ann Van Duyne Collerd, appear in this photograph by the J.H. Smith studio of Newark. Sadie is on the left and Bertha on the right. (Courtesy of Betsy D. Demarest.)

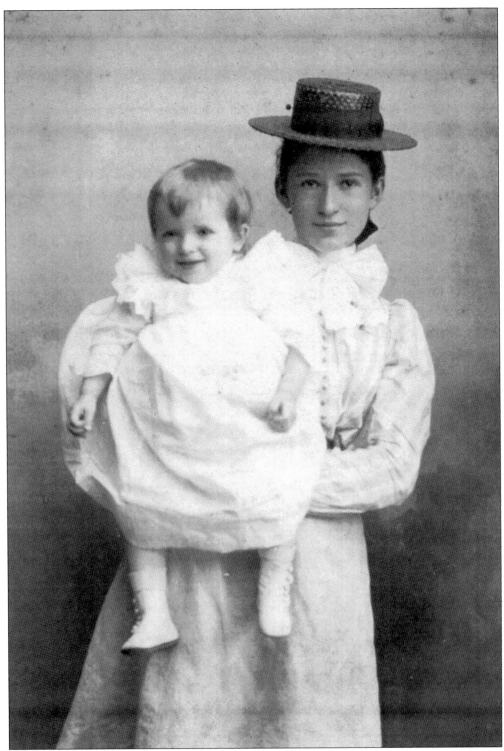

Bessie Collerd holds her sister Marion Collerd, in this lovely portrait by the Teush studio of Newark. (Courtesy of Betsy D. Demarest.)

Lucy Daneski was a teacher in the brick one-room schoolhouse on Taylortown Road in Montville in the early 1900s. She was born in Poland in 1892 and took the middle name of Hildred after becoming a self-taught teacher at approximately age 16. Her parents, Victor and Caroline Vloudowski Daneski, had a farm on Passaic Road, from which she walked to school. She later became the wife of Warren D. Kitchell. (Courtesy of C. Renee Kitchell Kramer.)

The sculptor Ulrick H. Ellerhusen (1879–1957), a Montville resident, was photographed in the Adirondacks c. 1940. One of his most renowned works was that of figures surrounding the colonnade boxes of the 1915 Palace of Fine Arts for the Panama-Pacific International Exposition at San Francisco. He lived on Hillcrest Avenue, up from Changebridge Road, in Montville. Two of the sculptor's works are on display at the Montville Historical Society Museum. (Montville Historical Society.)

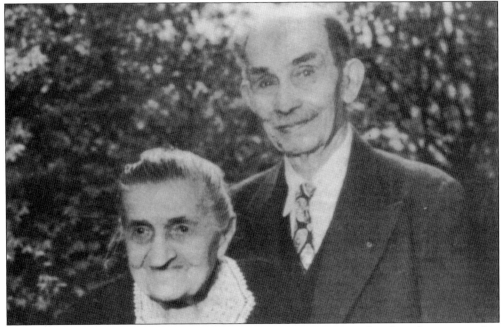

Mr. and Mrs. George Galla Sr. were 86 and 88 years of age, respectively, when they appeared in this newspaper photograph in honor of their 64th wedding anniversary. Both born in Austria, they came to Towaco in c. 1885, three years after emigrating to New York. They raised their family of three girls, Mary, Anna, and Susan, and three boys, John, George Jr., and Andy, at their home on Galla Road. (Courtesy of Dorothy Lewis.)

19

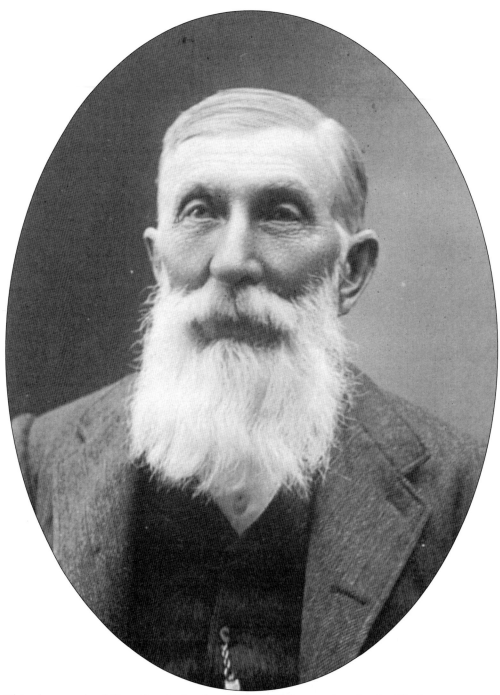

This photograph of Cornelius A. Jacobus (1834–1921) was taken by the Klughertz studio of Paterson. Jacobus built a home on Main Road at the corner of Jacksonville Road *c.* 1858. (Courtesy of Evelyn J. Kovarik.)

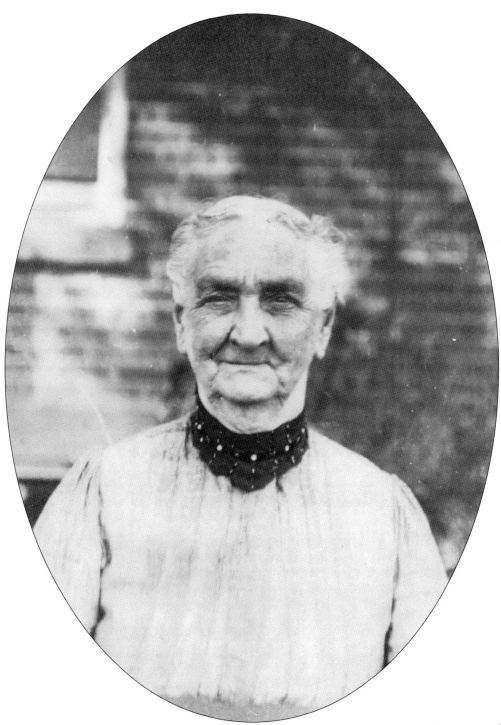

Mary Jacobus, nee Vreeland (1835–1916) was the wife of Cornelius A. Jacobus. (Courtesy of Evelyn J. Kovarik.)

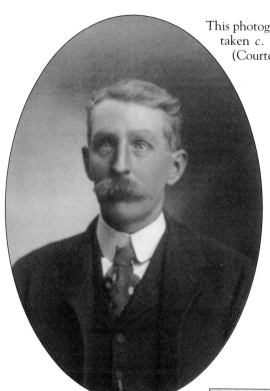

This photograph of Abram C. Jacobus (1872–1938) was taken *c.* 1904 by the Klughertz studio of Paterson. (Courtesy of Evelyn J. Kovarik.)

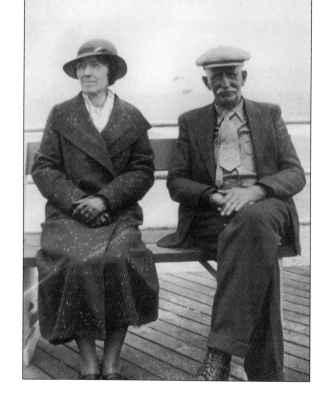

Abram C. Jacobus and his wife, Anna, nee Smith, appear in this photograph *c.* 1930. The couple lived on Main Road near Jacksonville Road in a home that is no longer standing. (Courtesy of Evelyn J. Kovarik.)

Raymond G. Jacobus (1864–1932) was one of the sons of Abraham R. and Phoebe Bott Jacobus. Born in Towaco, he worked for the Delaware, Lackawanna, & Western Railroad for 27 years. He then opened a popular store on the railway line in Towaco. His store specialized in groceries and general merchandise. (Courtesy of Evelyn J. Kovarik.)

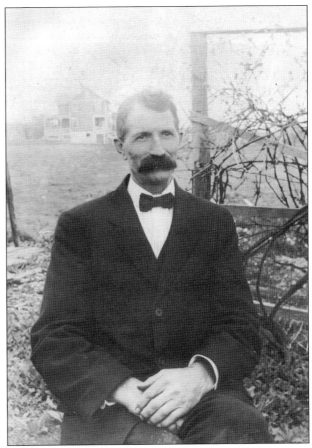

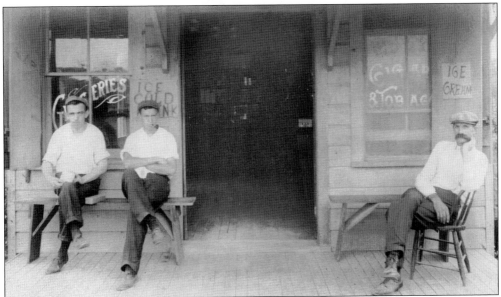

Raymond G. Jacobus is seen seated to the right outside of his Towaco store. (Courtesy of Evelyn J. Kovarik and Edith F. Metz.)

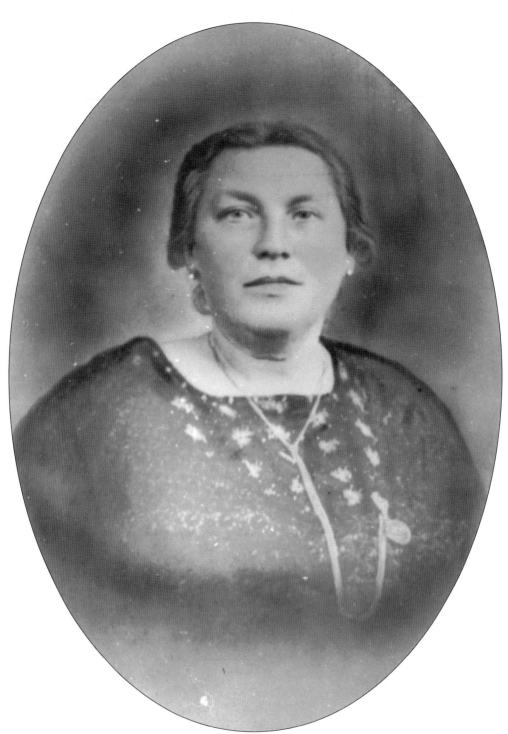

Lena Konner and her husband, Josef Konner, were the first Jewish family in Montville. They emigrated to New York from Austria in 1881, and after finding work in New York City and Newark, came to the Pine Brook section of Montville, where they purchased the Vreeland farm. In addition to founding the Sunrise Hotel in Pine Brook, they were the parents of a large family,

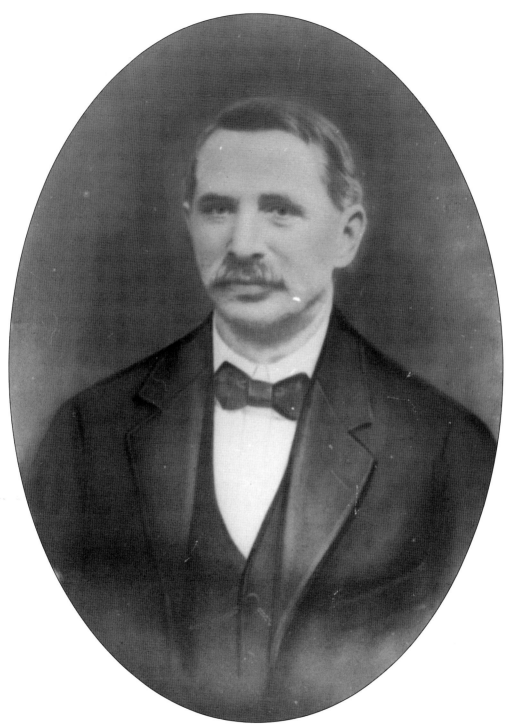

the founders of the first synagogue, and active members of the growing Jewish community. These hand-colored oval portraits are on display at the Montville Historical Society Museum. (Montville Historical Society.)

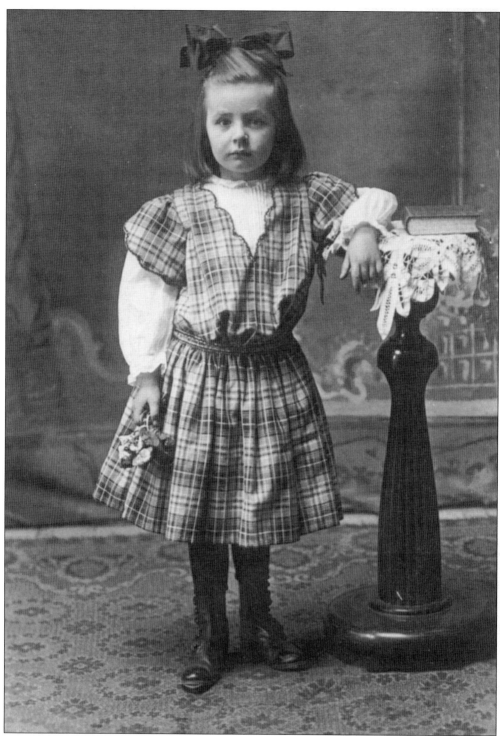

Marion Jacobus (1905–1990), whose married name was Metz (mother of Evelyn J. Kovarik, Edith F. Metz, and Marion D. Bauermann), is seen wearing a large hair bow and holding a nosegay in this portrait by the Klugherz studio of Paterson. (Courtesy of Evelyn J. Kovarik.)

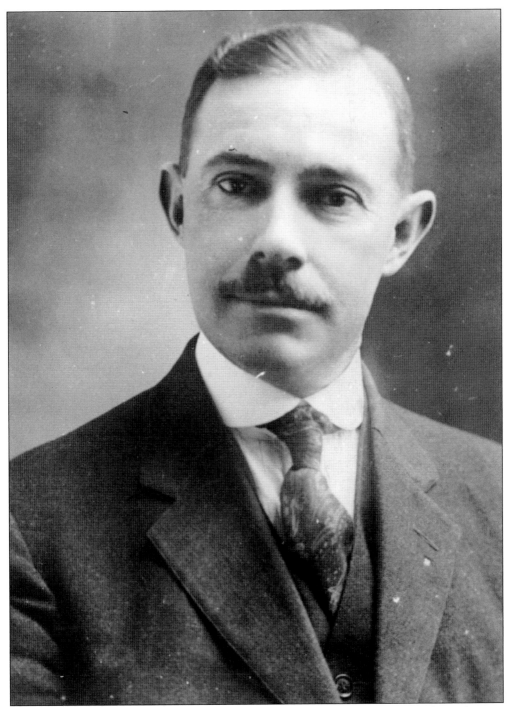

Dr. Frederick Longstreet was the Montville town physician. As part of his duties, he made visits to all the public schools approximately every two weeks to observe and examine the children. He maintained an office in his house at 228 Main Street, Montville. The well-annotated prescription book of another local doctor, Dr. R.S. Farrand, is on display at the Montville Historical Society Museum. (Montville Historical Society.)

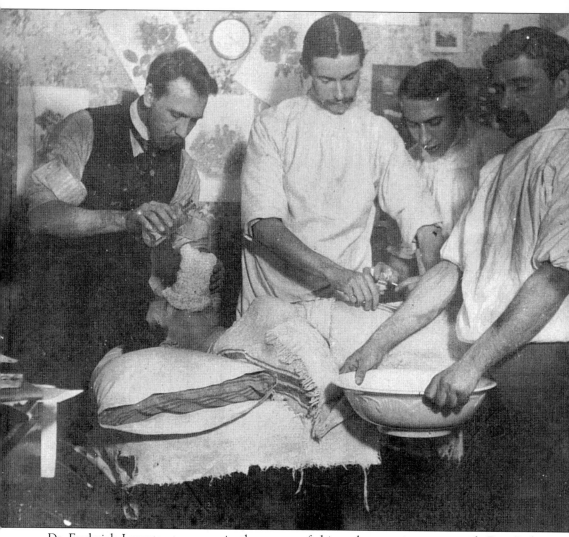

Dr. Frederick Longstreet appears in the center of this early operating scene with Drs. Bick, Bannar, Snyder, and Knight. He was a Manasquan native and an 1899 graduate of Hahnemann Medical College in Philadelphia. He married Montville resident Sarah Louise Cook in 1905. (Courtesy of Lorraine Cook.)

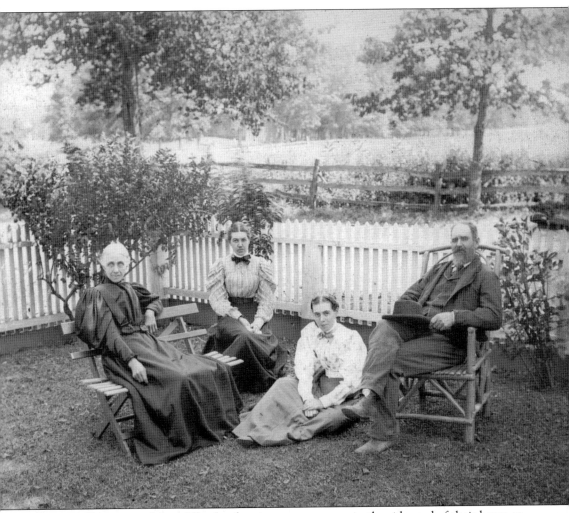

This c. 1887 portrait of the Miller family captures a moment in the side yard of their home at 56 Millers Lane. Seated, from left to right, are Charity Vreeland Miller (1841–1904), Ella Mary Miller (1871–1964), Nora A. Miller (1870–1940), and Christopher W. Miller (1838–1910). (Courtesy of Robert Starkey.)

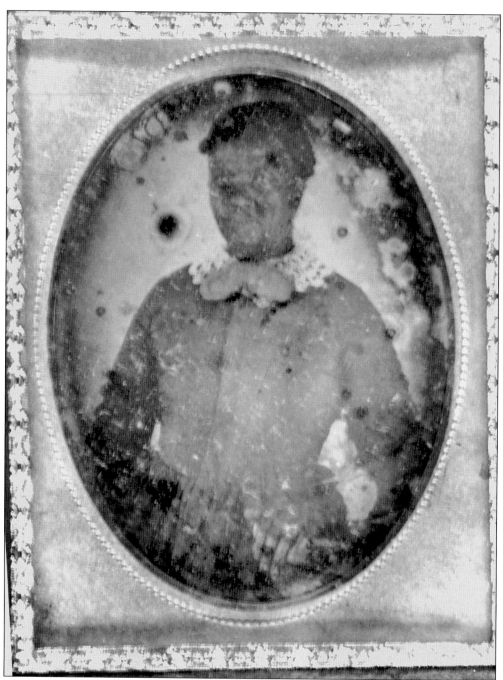

On this and the following page are daguerreotype images of wife and husband Elizabeth and Joseph Morris, who were former slaves on Montville farms. Elizabeth Morris, an accomplished weaver, was freed in 1826 by Mr. Duryea. In order to free their slaves, slave owners were required to apply for manumission, certifying that the individuals were capable of gainfully supporting themselves. This rare image, though faded through time, is a cultural testament that silently speaks volumes about the changes that Elizabeth Morris faced in her lifetime. (Courtesy of Betsy D. Demarest.)

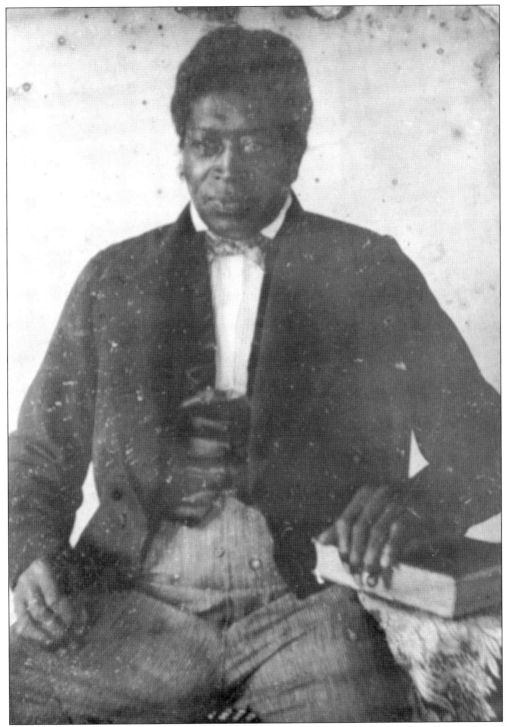

Joseph Morris, a former slave freed by Daniel S. Van Duyne in 1827, purchased property on Maple Avenue in Pine Brook and built his home there. (Courtesy of Betsy D. Demarest.)

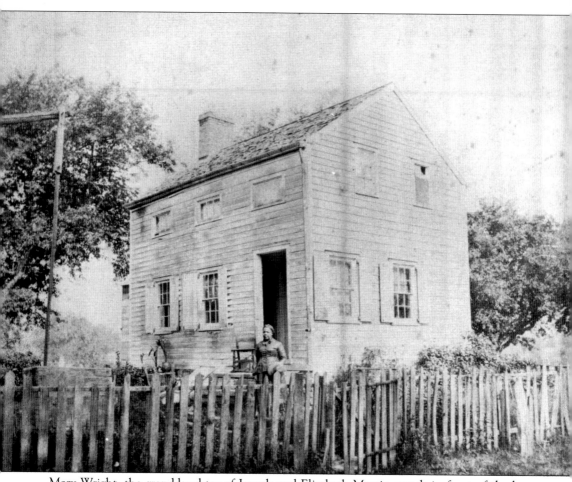

Mary Wright, the granddaughter of Joseph and Elizabeth Morris, stands in front of the house that her grandfather built on Maple Avenue, near the corner of Bloomfield Avenue. (Courtesy of Betsy D. Demarest.)

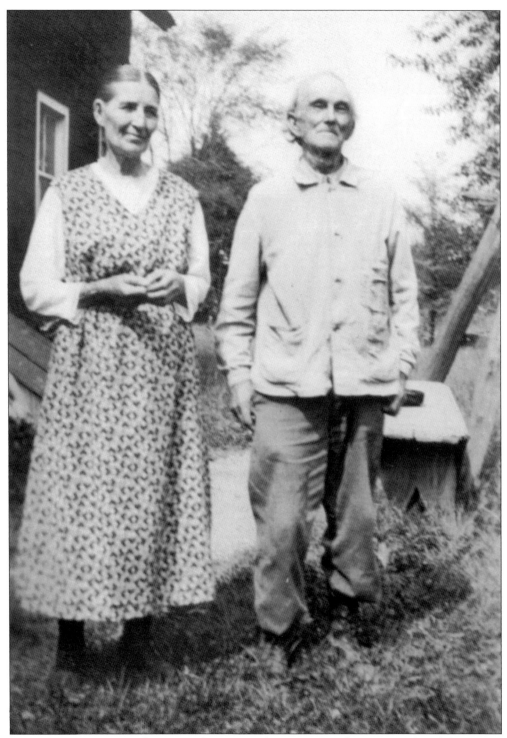

Mr. and Mrs. James Smith, maternal great-grandparents of Evelyn J. Kovarik, Edith F. Metz, and Marion D. Bauermann, pose for a photograph in the 1930s at Towaco. (Courtesy of Evelyn J. Kovarik.)

Mary Mandeville Van Duyne was the wife of Cornelius Van Duyne and lived up near the cider mill on Pine Brook Road. At only 4 feet tall, she was known as "little grandmother" and died at the age of 95 in 1875. She was the great great-great-grandmother of Betsy Demarest. (Courtesy of Betsy D. Demarest.)

Raymond Vanderhoof enjoys cooling off in a tin wash basin outside the family homestead at 57 River Road in this *c.* 1934 photograph. (Courtesy of Steve Hrobak.)

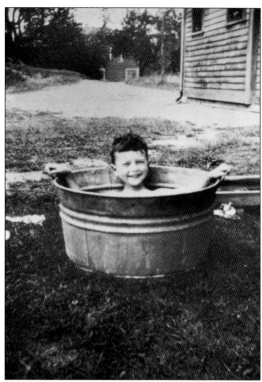

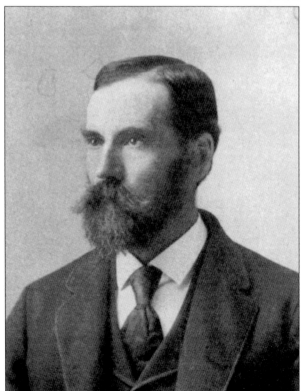

John Wilson Van Duyne, son of Abraham C. and Hetty M. (Crane) Van Duyne, was born at the family farmhouse in 1844. He and his first wife, Abbie R. Husk, were the parents of three children. After her death in 1878, he married Ada M. Jacobus and had three more children. He founded the Van Duyne Cider Mill on Pine Brook Road and served as assessor for the township. (Montville Historical Society.)

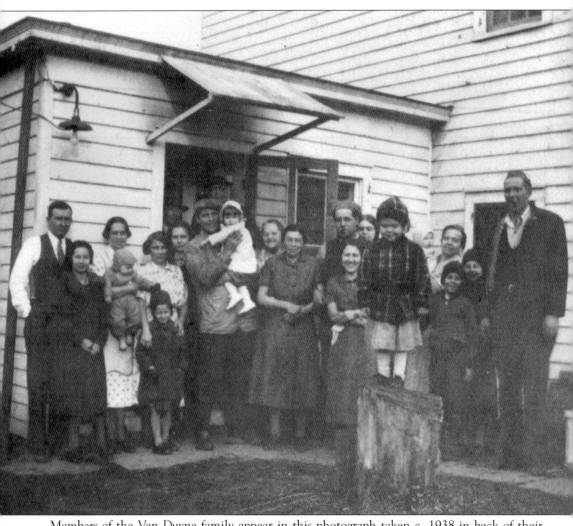

Members of the Van Duyne family appear in this photograph taken *c.* 1938 in back of their house on Pine Brook Road, opposite the Van Duyne Cider Mill. Harvey Wilson Van Duyne, to the left of center, holds his daughter, who is the present owner of the cider mill, Doris Heddy. (Courtesy of Doris Heddy.)

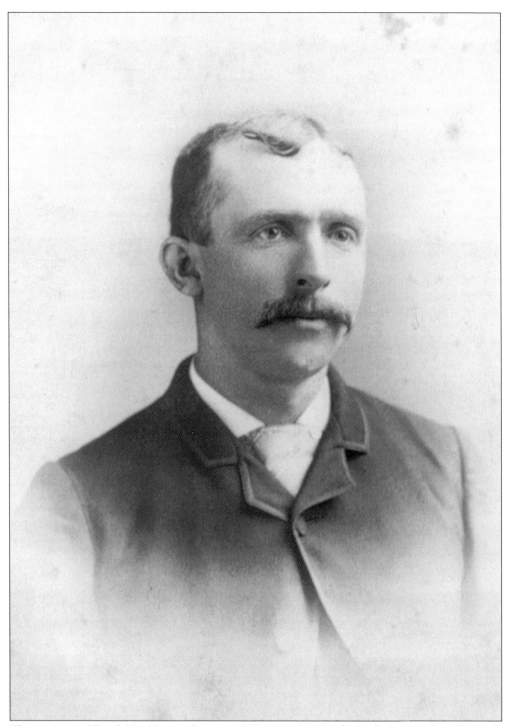

This portrait of Frank Van Duyne, born in 1861, was taken by the Perkinson studio of Newark and New York. He was one of five children of Nicholas and Rachel Van Ness. His paternal great-grandfather, Henry, came from Holland in 1722 and built a cabin on the Passaic River in the same year. (Courtesy of Betty Pyontek.)

Georgianna Bush Van Duyne, born in 1862, was also photographed by the Perkinson studio. She and her husband, Frank Van Duyne, were the parents of Willard, Frank Jr., Weldon, and Marguerite Van Duyne. (Courtesy of Betty Pyontek.)

Weldon H. Van Duyne was 14 years old when he sat for this portrait in 1910. His farm was located adjacent to the cider mill on Weldon Place. (Courtesy of Betty Pyontek.)

Nancy Van Riper Tappen was the twin sister of John Van Riper. The twins' birthday was June 4, 1867. (Montville Historical Society.)

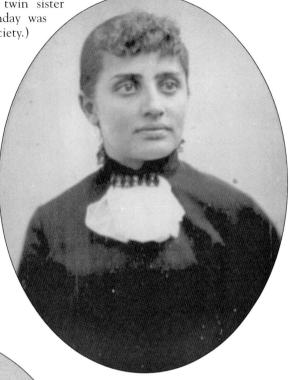

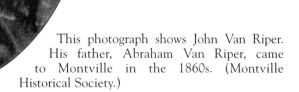

This photograph shows John Van Riper. His father, Abraham Van Riper, came to Montville in the 1860s. (Montville Historical Society.)

Farmer Henry F. Witty (1836–1916) and his wife, Sarah Witty (1834–1920) were both from England. They are shown outside their Waughaw Road home. Their son Ward Witty served on the Township Committee from 1916 to 1938, including several years as chairman. Their great-grandson Albert Witty served on the Township Committee for seven years. (Courtesy of the Witty family.)

Dr. Maretta H.C. Woodruff (1874–1912) was a physician practicing in the Boonton-Montville area. A daughter of Judge Crane of Montville, she married Christopher Woodruff. (Courtesy of Steve Hrobak.)

Two

THE MORRIS CANAL LEGACY

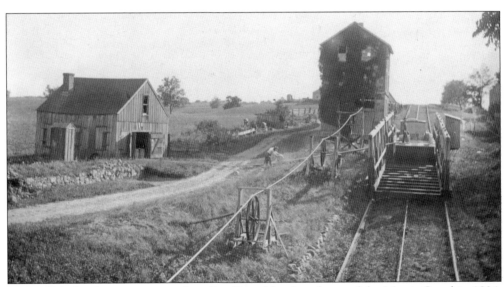

Montville's development was profoundly affected by the advent of the Morris Canal in 1824. The inland waterway, which stretched from Phillipsburg on the west to the eastern terminus at Jersey City's Hudson River docks, was a technological marvel of its day. It spanned the many miles of uneven terrain by the ingenious use of locks and inclined planes, angled slopes with rail-guided wood cradles designed to transport canal boats up and down their length. The canal was widened by 1860, and for many decades it was a vital link for commerce and recreation, supporting its own culture and ways. In this photograph of Plane 9 East, the three-story plane house (powerhouse) is visible on the hill to the right of center. A boat is being loaded with barrels of tar from the shed to the left. Tar was used in routine maintenance of the hulls of canal boats, as well as for cable lubrication and rust prevention. (Montville Historical Society.)

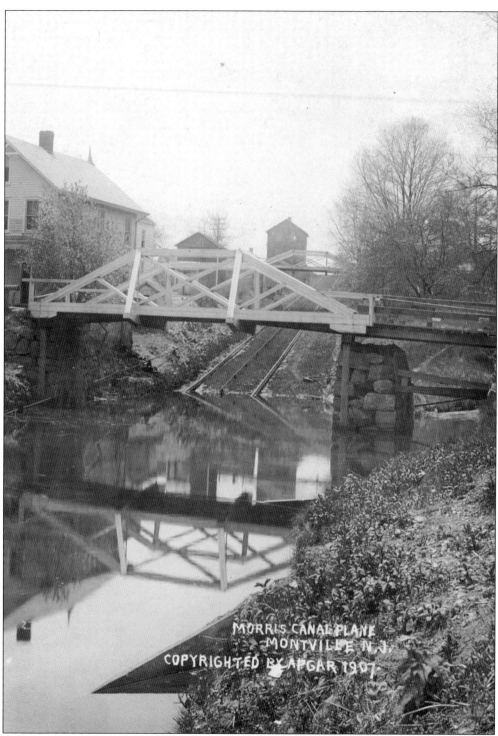

MORRIS CANAL PLANE
MONTVILLE N.J.
COPYRIGHTED BY APGAR 1907.

Plane 9 East spanned an elevation of 74 feet. This view looking west shows the canal and plane during a long pause in navigation. The postcard was copyrighted by Apgar in 1907. (Montville Historical Society.)

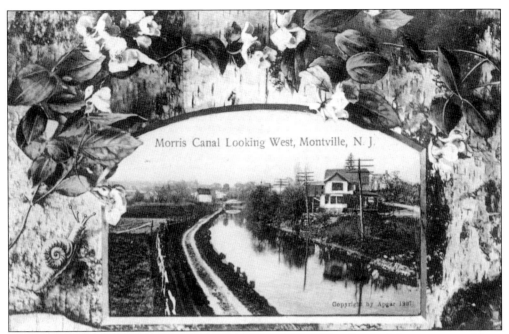

This view shows Montville from the head of Plane 8 East. The Capstick houses are visible at the left. (Montville Historical Society.)

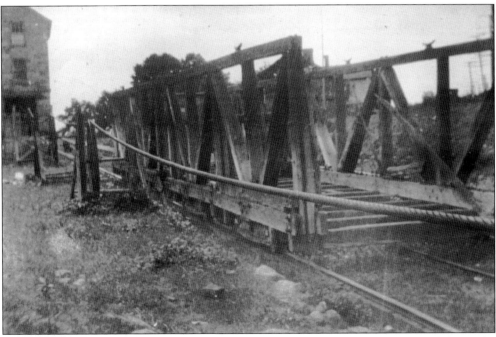

The trussed wood cradle, called a plane car, was used to transport boats up and down the inclined planes, as seen at Plane 9 East, looking west. Plane car wheels were double-flanged to hold the car on the 11-gauge rails. The slack cable and sheave are visible in the foreground. Note the other portion of the continuous cable fastened below the plane car. (Montville Historical Society.)

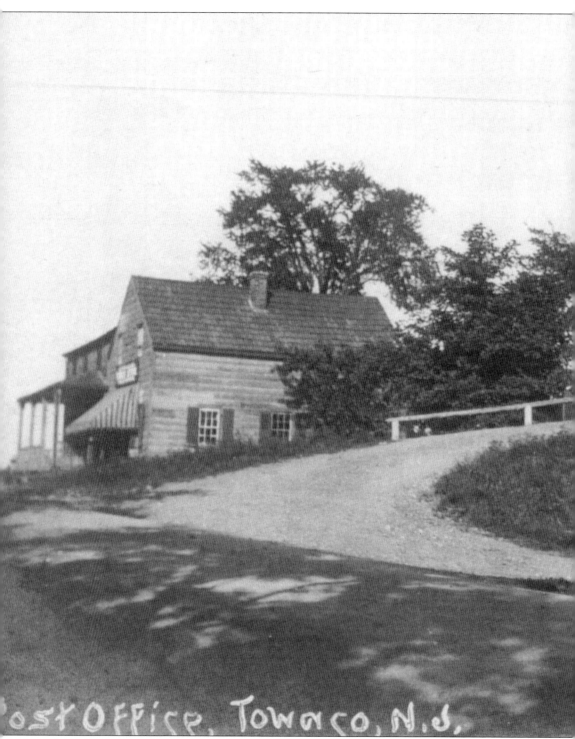

Post Office, Towaco, N.J.

This postcard view features the post office and the Lester Jacobus store (see page 77) along the Morris Canal at Bridge No. 97 on Pine Brook Road in Towaco. Note the two men to the right, along the canal towpath. The gable of the present-day Witty house (formerly the Baldwin

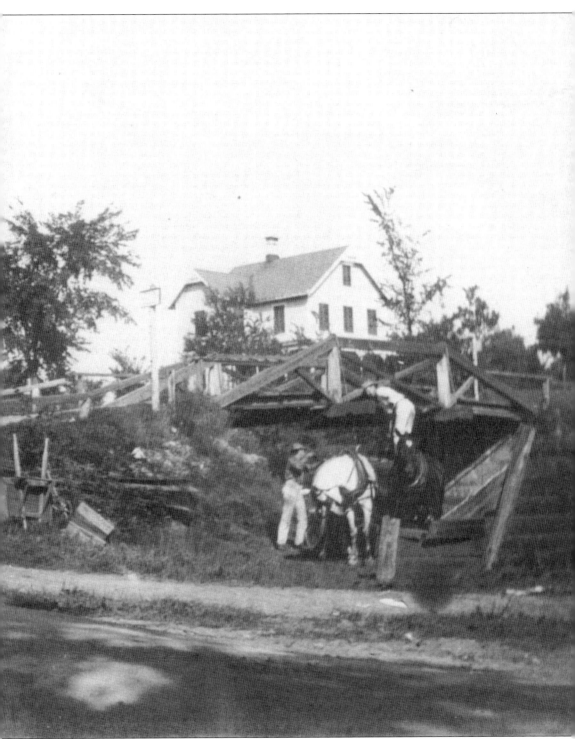

house) is visible just behind the canal bridge. The team and wagon in the foreground are working at the former Van Ness coal and lumberyard. On the Morris Canal, a black-and-white combination such as this one was called a Jersey team. (Montville Historical Society.)

Pausing at the bridge over the canal at White Hall Methodist Church in Towaco *c.* 1915 are, from left to right, William Kiemel, Jesse Vreeland, and Albert Brendler. (Courtesy of Jean and Floyd Brendler.)

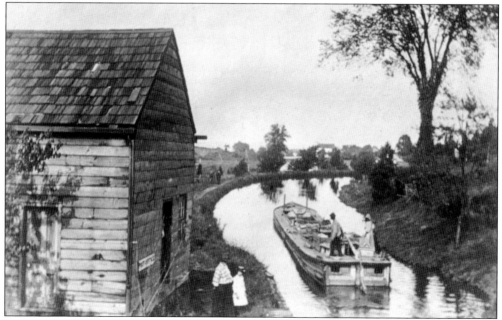

In this *c.* 1900 view, the canal post office at Towaco is on the left and an articulate, or hinged, canal boat has departed the dock. By 1860, the canal had been widened and boats of greater tonnage could be accommodated; boats joined at the center were able to negotiate the incline planes of the canal more easily. (Montville Historical Society.)

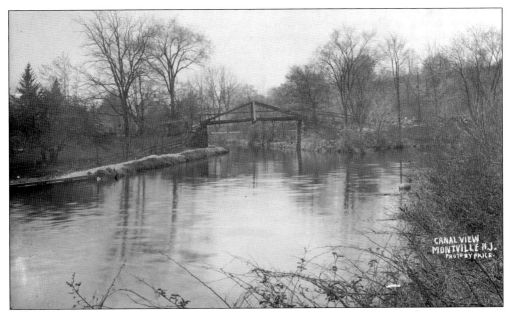

The canal's scenic beauty was captured in this postcard by the Price Studios of Dover, Boonton, and Clinton. Apart from its role in commerce, the canal also served as a ready source of water for the local firefighters. Canal bridge inspectors would traditionally carve their initials and inspection date into the massive timbers. (Montville Historical Society.)

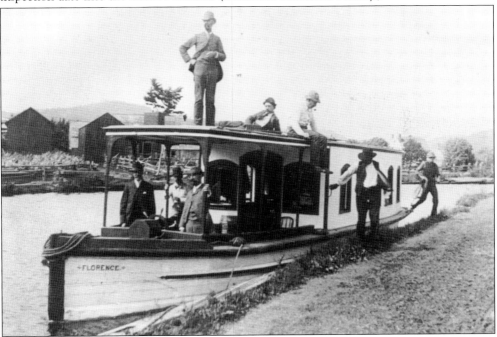

The pay-boat *Florence* was also used for monthly inspections by the Morris Canal and Banking Company on which to record conditions along the route. It was named after the daughter of the superintendent, William Powers. Earlier, the boat had been the *Katie Kellog* after the wife of the former superintendent, William Kellog. Unlike most of the mule-drawn boats on the Morris Canal, this vessel was self-propelled. (Montville Historical Society.)

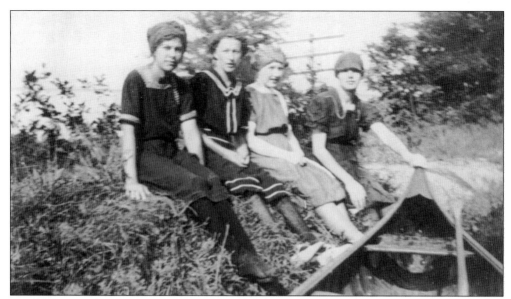

From fishing and swimming and boating in the summer to ice-skating in the winter, the canal offered many forms of recreation. Four unidentified young women are dressed for a canoe outing in this candid view. (Courtesy of the Witty family.)

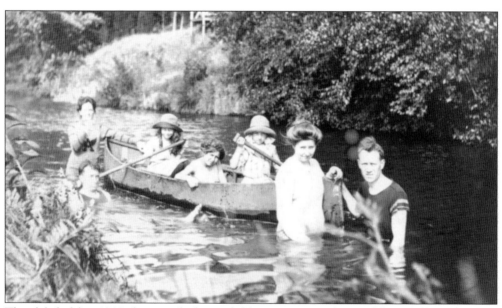

This delightful c. 1918 photograph shows children practicing their paddling skills, with adults nearby for safety. Shown from left to right are Lena Lindenhauer, William Kiemel, Edna Lindenhauer, Mabel Lindenhauer, Florence Lindenhauer, Florence Titman Brendler, and Henry Brendler. (Courtesy of Jean and Floyd Brendler.)

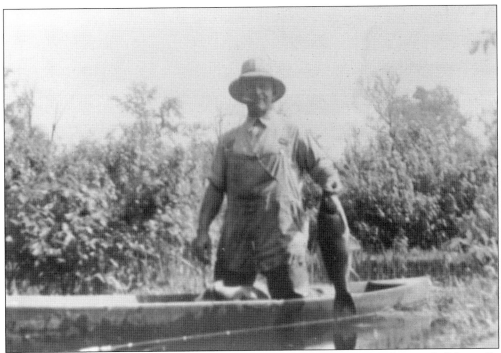

Weldon Van Duyne holds an impressive catch during a day of fishing in the canal. (Montville Historical Society.)

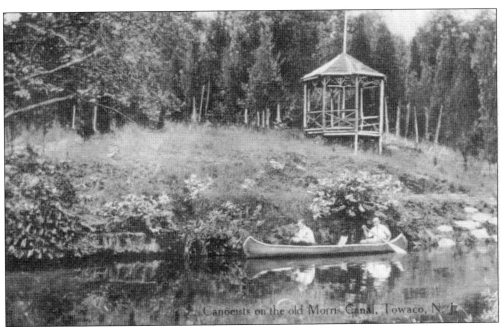

Canoeists glide along the Morris Canal past the rustic gazebo on the Brendler property in Towaco. (Courtesy of Evelyn J. Kovarik and Edith F. Metz.)

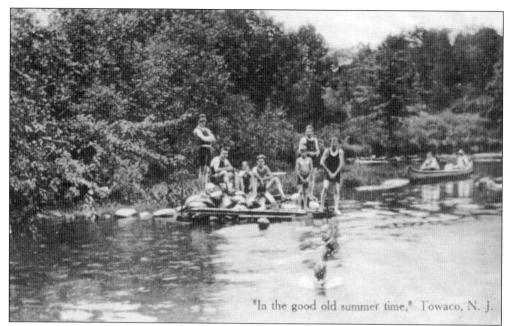

"In the good old summer time," Towaco, N. J.

Canoeing and swimming and the joys of summer are celebrated in this postcard scene in Towaco. (Courtesy of Evelyn J. Kovarik and Edith F. Metz.)

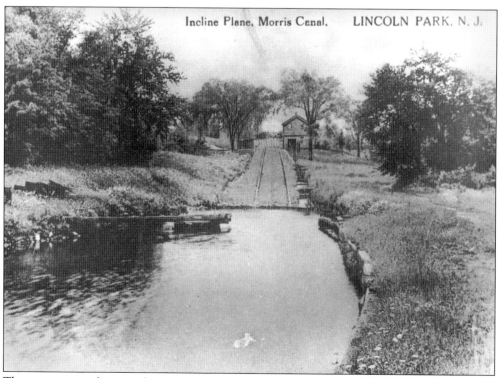

Incline Plane, Morris Canal. LINCOLN PARK, N. J.

The easternmost feature of note along the Morris Canal through Montville was at Plane 10 East, at the border of Montville and Lincoln Park. This view is from the basin at the bottom of the plane in Lincoln Park. (Montville Historical Society.)

Three

MONTVILLE

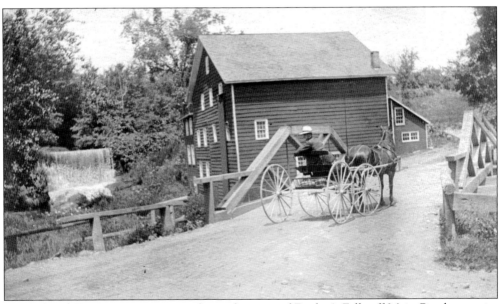

Dr. Frederick Longstreet pauses to take in the view of Decker's Falls off Main Road, opposite the Van Riper Real Estate and Insurance building. Decker's Mill was operated by William Decker, a Boonton resident who served in the Civil War in the 1st New York Mounted Rifles under General Kilpatrick. He operated a saw -mill for 18 years and was engaged in teaming. This location was considered the center of Montville in days past, with the Morris Canal and commercial interests located in close proximity. (Courtesy of Lorraine Cook.)

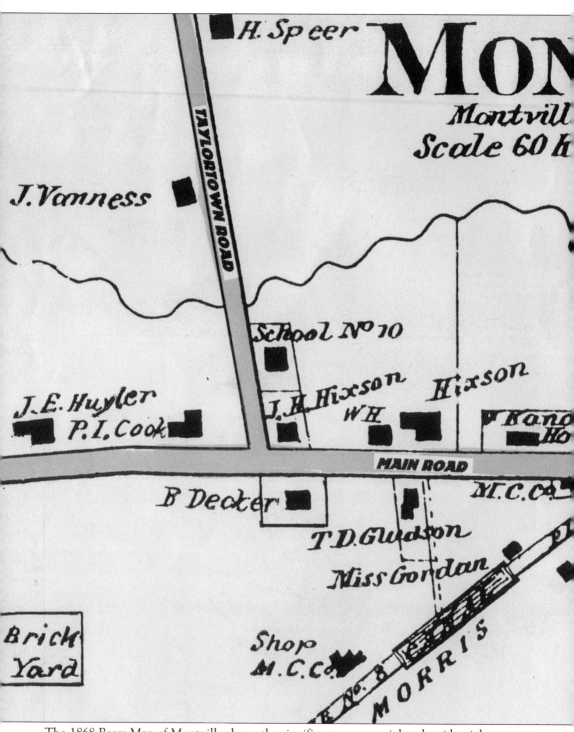

The 1868 Beers Map of Montville shows the significant commercial and residential structures present in Montville at the time. Note the clusters of structures along the canal route. The canal experienced its greatest prosperity between 1845 and 1866. It was dismantled by the State of New Jersey starting in 1924, leaving only remnants of the locks and basins and, for many,

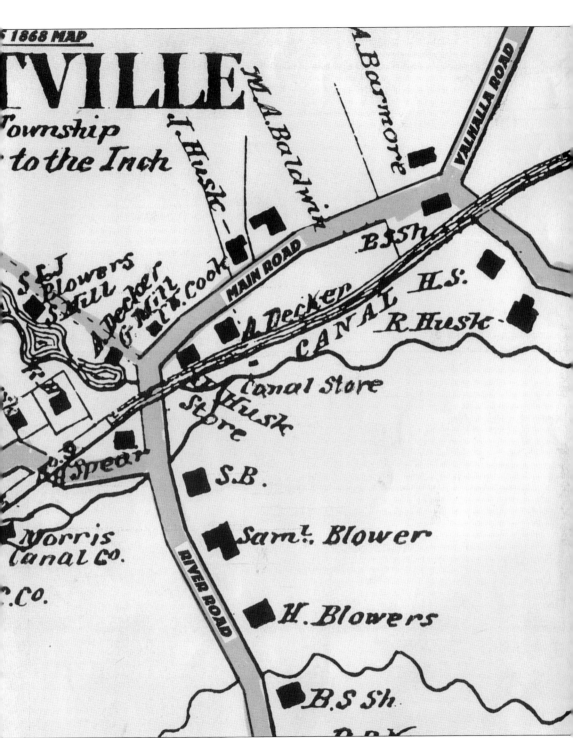

cherished memories. Cornelius Vermeule, the engineer in charge of the canal demolition, drew plans of the canal and its engineering features. Today, the Vermeule drawings are some of the canal's best contemporary documentation. (Montville Historical Society.)

Blowers' sawmill was situated along Crooked Brook, which feeds into the Rockaway River. Flour and gristmills were also located along the river, using water to power their machinery. (Courtesy of Steve Hrobak.)

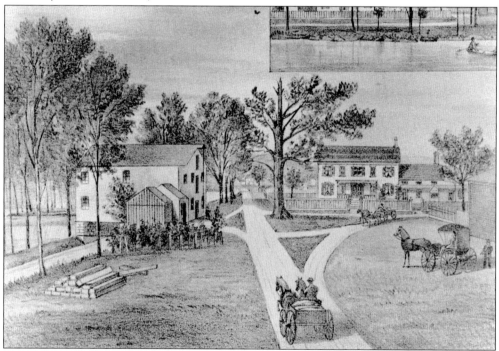

Traces of a foundation, wheel pit, and tailrace are the remaining vestiges of the Zabriskie Gristmill, on the Rockaway River along River Road and at the foot of Church Lane. The 1868 *Morris County Map and Atlas* features this depiction of the residence and flouring mill. (Montville Historical Society.)

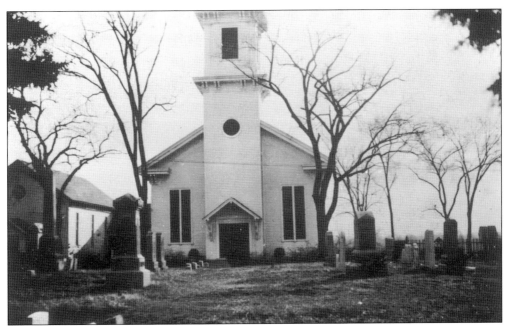

The Dutch Reformed Church, founded in nearby Boonton, was established in 1756. It obtained a regular meeting site and built a church at this location in 1818. After that building was destroyed by fire, the structure shown in this 1938 photograph was constructed. (Montville Historical Society.)

The A.H. Zabriskie house at 103 Changebridge Road and Church Lane appeared on the 1853 Lightfoot Map of Morris County. The property was a working farm into the 20th century. (Montville Historical Society.)

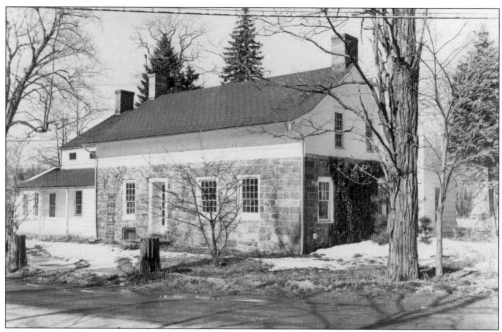

The oldest portion of the Johannes Parlaman house, at 15 Vreeland Avenue, dates from *c.* 1755. An addition in 1780 and one in 1829 reflect expansion without compromising the historic integrity of the structure. Documented by the Historic American Buildings Survey, the house remained in the possession of the original family for over 200 years. (Montville Historical Society.)

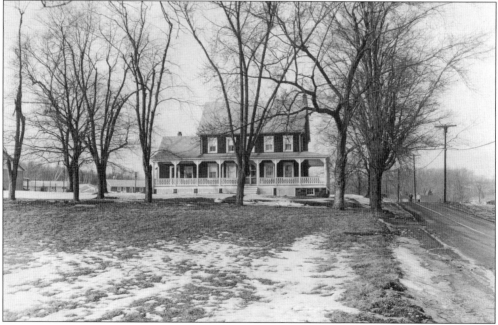

The Cornelius Hamma house at 65 River Road (later, Conklin Farms) preserves the setting of a working farm. The one-story portion, to the left in the photograph, appeared in the 1853 *Morris County Atlas*. (Montville Historical Society.)

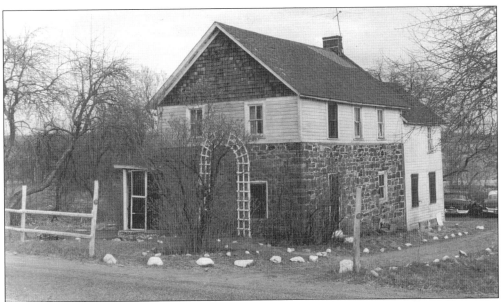

The James P. Hiler house is a pre-1805 fieldstone structure of the block-and-wing type. It was a dairy farm until the property was cut through by the Morris Canal. It retains its original beams, ceiling, floors, and fireplace but is otherwise considerably altered as a one-story Dutch stone farmhouse. (Montville Historical Society.)

The True Dutch Reformed Church was formed after Rev. J. Brinkerhoof and a small group broke away from the Dutch Reformed Church (see page 55) because of a doctrinal dispute in 1824. Located on Changebridge Road, the church building eventually became part of a neighboring property and was used as a garage until it was accidentally demolished. The church cemetery still exists on the same road. (Montville Historical Society.)

This early Taylortown schoolhouse was located on the corner of Boonton Avenue near Taylortown Road. Abandoned in the early 1900s, the building is shown in 1936—an empty and unpainted frame structure. (Courtesy of Steve Hrobak.)

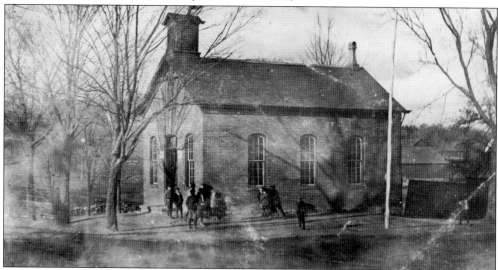

This brick schoolhouse, with its high segmentally arched windows, was constructed in 1867 by Mr. Hixson on Taylortown Road. The land was given to the town with the proviso that it be used for civic purposes or else it would revert to the original owner's family. The high-ceilinged interior consists of one large room, which was heated by a coal stove. An anteroom adjoining the entry had hooks for the students' lunch pails and a dipper for well water. The building was used as a Methodist meeting hall and for township temperance meetings in the 1890s. It became a town hall in 1911 and a post office in 1939. It is now home to the Montville Historical Society Museum. Note the cupola atop the front gable. (Montville Historical Society.)

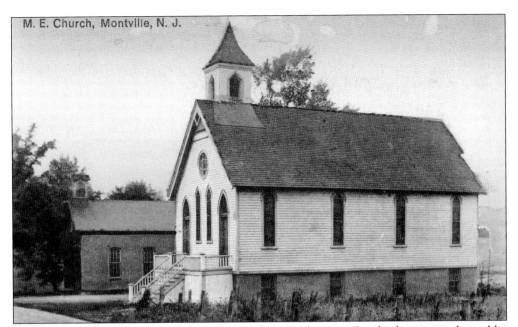

M. E. Church, Montville, N. J.

The Methodist Episcopal Church was located on Taylortown Road adjacent to the public school, which can bee seen in the background at the left. Since the time that this postcard view was taken, the church has been altered for commercial use and the school has become the Montville Historical Society Museum. (Montville Historical Society.)

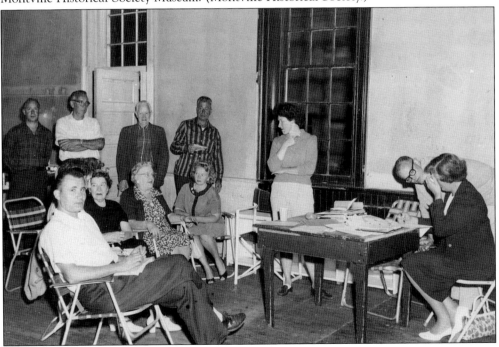

An early meeting, c. 1962, including several founders of the Montville Historical Society, was held in the former school building. Among those present were Bill Cook, John Sashenoski, Bill Richards, Archie Smock Jr., Teddy Murphy, Bill Christianson, and Mrs. Longstreet, seated in the center. (Montville Historical Society.)

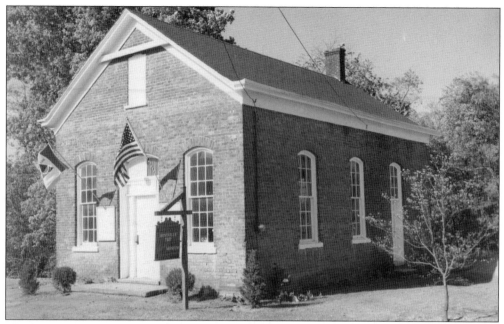

The Montville Historical Society is dedicated to preserving and interpreting the rich history of the community. It maintains research files and a fine collection of local memorabilia. The society was founded on September 15, 1964, an outgrowth of the Tercentenary Committee (1962–1965). (Montville Historical Society.)

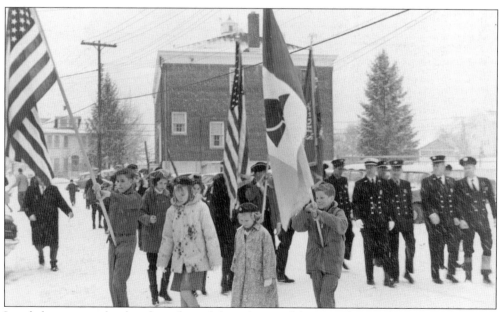

Local elementary school students formed the color guard for a parade on February 24, 1962. The parade marked the dedication of the former schoolhouse and municipal building as a museum, which opened in 1963. The firehouse at the corner of Taylortown and Main Roads is visible in the background. (Montville Historical Society.)

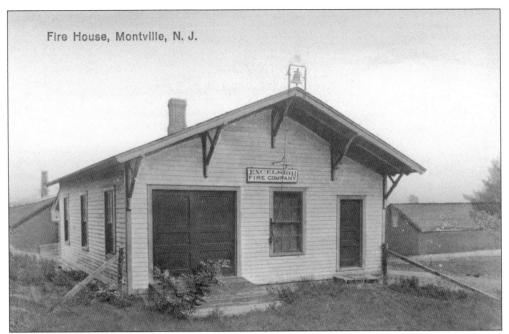

Fire House, Montville, N. J.

The Excelsior Fire Company was built by volunteers in 1911, with material assistance from John Capstick & Sons, to provide fire protection to for the mill complex and the community at large. The building served as an active firehouse until 1934 and is now used by the fire department to store antique apparatus. (Montville Historical Society.)

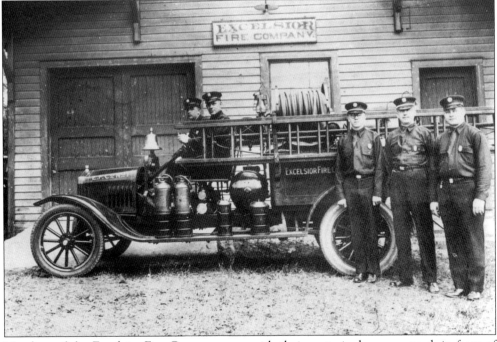

Members of the Excelsior Fire Company pose with their motorized pumper truck in front of the firehouse. It was determined by a referendum that the department should use motorized apparatus rather than horses in 1917. (Montville Historical Society.)

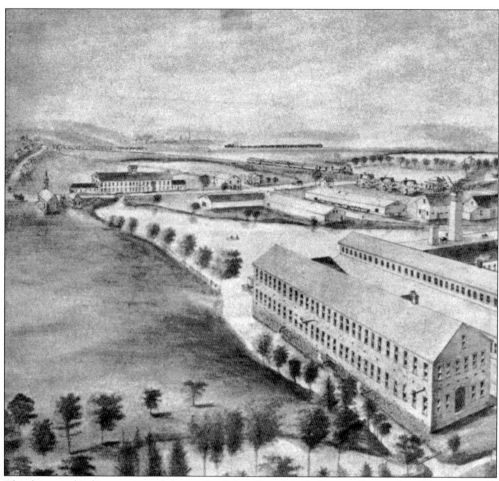

This historic bird's-eye view of shows the John Capstick & Sons mill complex. The Capsticks controlled two related businesses: Columbia Print Works and Globe Print Works. Note the Methodist Episcopal Church and the schoolhouse (now museum) in the upper left. This period advertisement printed for the firm describes the company's work as "bleachers, dyers, printers

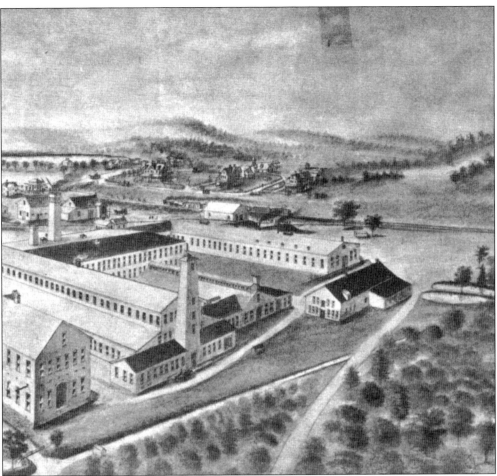

& finishers." Cotton, linen, jute, and wool were finished at what was considered "one of the best equipped establishment of its kind in the United States." The mills and storehouses were connected by the railroad line, with ample coal and water readily available. Fire destroyed most of the mill in 1914. (Montville Historical Society.)

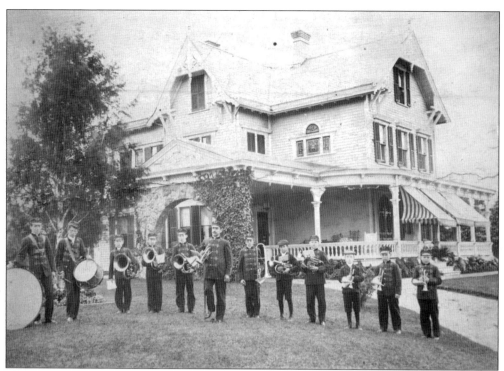

This historic photograph shows the Capsticks' marching band on the lawn in front of one of the three mansions built by John Capstick for himself and his two sons, John Jr. and Thomas Capstick, in 1884. (Montville Historical Society.)

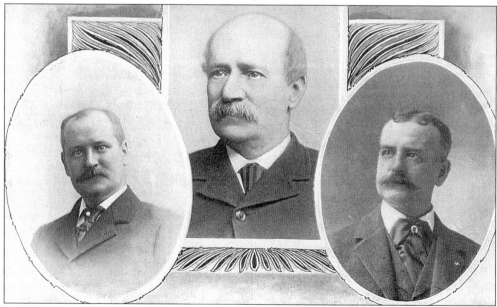

John Capstick, center, the company founder, is pictured with his sons Thomas Capstick, left, and John Capstick Jr., right. The mill complex is part of the Capstick Historic District designated by Montville's Historic Preservation Review Commission. (Montville Historical Society.)

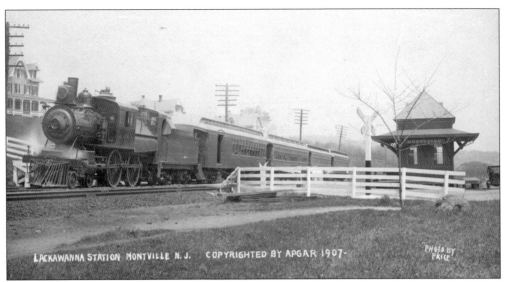

In this 1907 postcard view of the Lackawanna (DL & W Railroad) Station at Montville, one of the Capstick mansions is visible in the upper left. The homes were built to overlook the railroad tracks, and their commercial holdings. This double-track portion of the Boonton line was grade separated and expanded to four tracks in 1925. The locomotive pictured was called a "Mother Hubbard on Camelback" because of the unique mid-boiler position of the cab. This design was necessitated by an extra wide grate and firebox for burning anthracite coal. (Courtesy of Evelyn J. Kovarik and Edith F. Metz.)

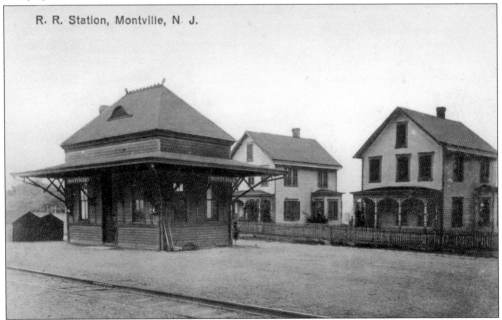

This postcard of the foremen's row of houses behind the station shows the alignment of homes of the Capstick officials on the side of the railroad tracks opposite the mansions upon the hill. A mill store was located nearby, where workers could exchange mill currency for needed supplies. The station was demolished in the early 1960s after the stop was discontinued. (Montville Historical Society.)

65

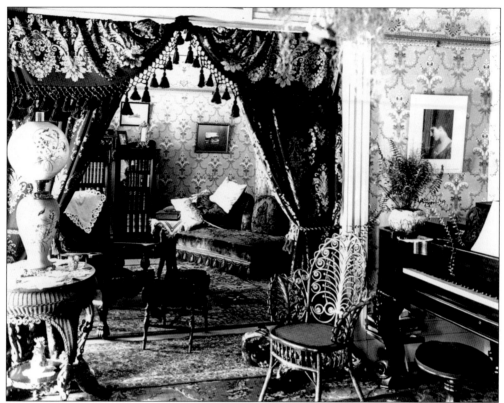

This historic interior view illustrates Victorian opulence. The printed draperies seen on the portiere and elsewhere are illustrative of the textiles manufactured by the works. (Montville Historical Society.)

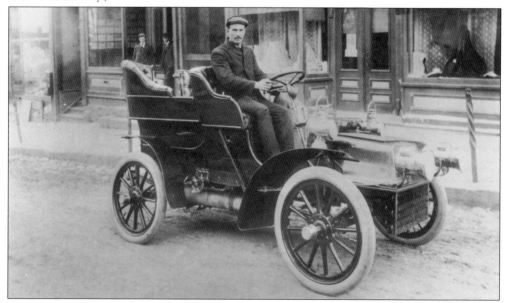

John Capstick's chauffeur, Edward Stickle, is at the wheel of a Cadillac in this 1904 photograph, taken on Main Street in nearby Boonton. (Courtesy of Steve Hrobak.)

The icehouse for the Capstick complex, built in 1880, served the important purpose of providing ice for commercial purposes. It still stands. (Montville Historical Society.)

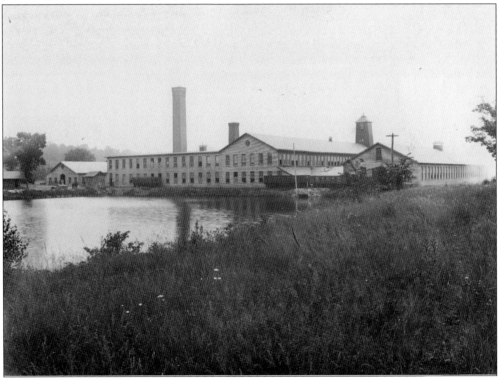

Brick square-based chimneys rise up from the Capstick mill works, seen from across the millpond. Note the railroad spur track and freight cars on the top of the dam for the lower millpond (now drained). This view was taken from the rear of the brick schoolhouse (now museum) property. The mill burned in 1914 and was never rebuilt. (Courtesy Steve Hrobak.)

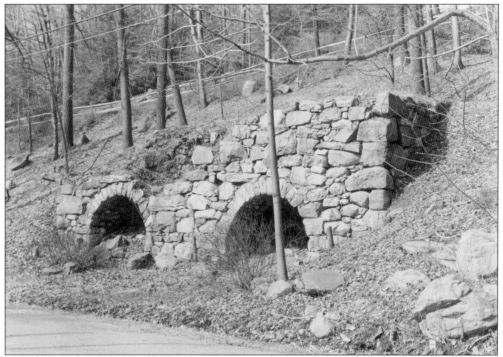

The lime kiln of Lake Shore Drive on Lake Valhalla, near the summer home built for the Capstick family, dates from the 1820s, when lime was taken to the iron foundries at Boonton by horse and wagon. (Montville Historical Society.)

This simple cabin of planed wood, 2 miles above Lake Valhalla, was a solitary home in the vicinity for many years. Jake and Eliza Jane Cookerow lived here with their three sons. Eliza Jane Cookerow walked to Montville and Boonton each day to earn a living doing laundry and housework. (Montville Historical Society.)

Two log and rubble stone cabins were built by the Cookerow brothers near the summit of Turkey Mountain. This, the larger of the cabins, had two rooms, each with a fireplace. The gate of the livestock corral is visible along the rear, or north side, of the structure, and a grape arbor existed along the south side. (Montville Historical Society.)

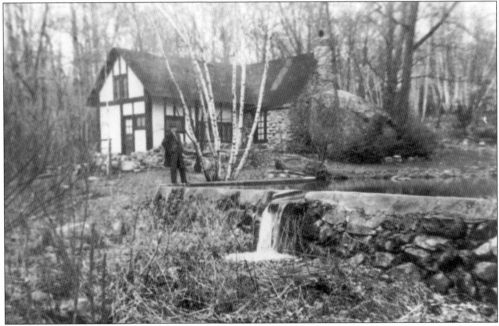

The nonprofit Habberstad Project Inc. has studied and catalogued 16 unique cottages designed and built by Claude and Helen Habberstad during the years of the Great Depression. Four cottages are on Taylortown Road, including "Stoneby," pictured here. Stoneby was named for the enormous boulder that buttresses one end of the house, visible to the right of the house. Howard Buck, the home's original owner, is in the foreground. The unusual design elements of the recently completed home were featured in an article in the *Morristown Daily Record* in September 1932. Other craftsman Vernacular-style homes border Taylortown Road. (Courtesy of the Buck family and the Habberstad Project Inc.)

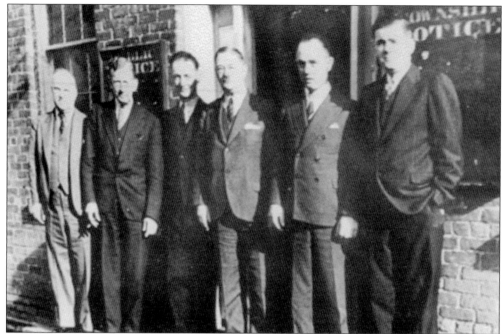

Members of the Montville Township Committee were photographed in 1939 outside town hall, the present site of the Montville Historical Society Museum. They are, from left to right, Charles Ashley, treasurer; James Holbrook, clerk; and committeemen Michael Herman, William Turner, George Van Riper, and attorney David Young III. (Montville Historical Society.)

These students of the Linwood School, formerly on Route 202 in Montville, are thought to be in either the fourth- or fifth-grade class, c. 1918. Anna Rimek Riker is on the far right in the second row. The Linwood school building was also used as the town hall and library for several years. Today, it is a senior center. (Montville Historical Society.)

The legendary Russ Hilbert, Montville's first policeman, is seen at a summer gathering. (Courtesy of Steve Hrobak.)

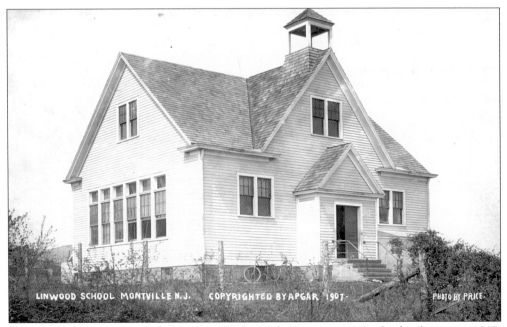

This exterior view shows the Linwood School during its period of school use, in 1907. (Montville Historical Society.)

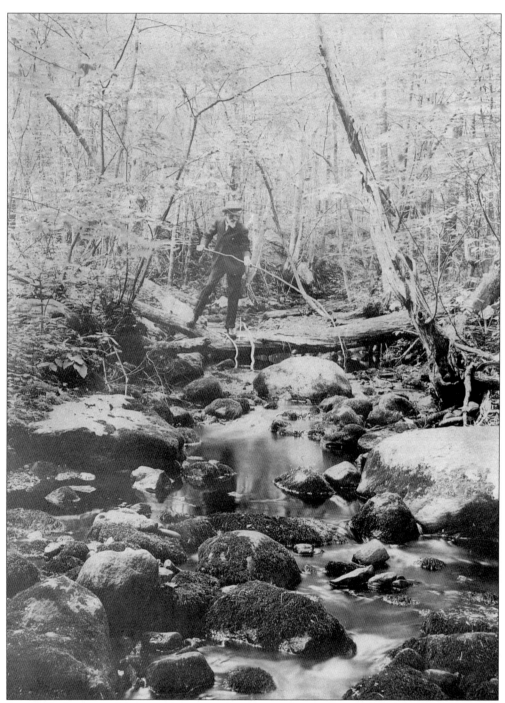

Asa T. Cook is seen fishing in the tranquil stream in front of his property in this view, which captures the wooded beauty of Montville. Cook was a farmer as well as a store owner. He served as assessor from 1876 to 1890. The stream in front of his house on Main Road fed into the Morris Canal. (Courtesy of Lorraine Cook.)

RESIDENCE A. T. COOK AND CORNERS, MONTVILLE, N. J.

The Christopher Barmore house, also known as the Asa Cook house, is located at 228 Main Road, at the corner of Valhalla Road. It incorporates a first-floor stone section dating to 1785 with an 1888 Queen Anne-style addition. (Montville Historical Society.)

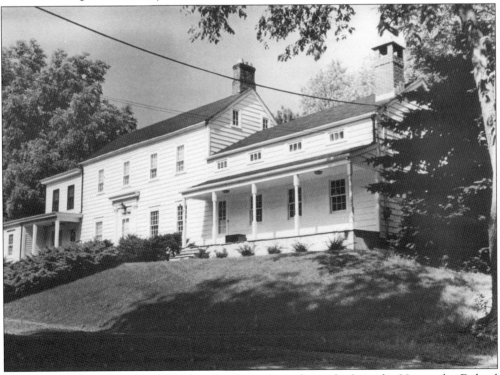

The R.H. Doremus house at 263 Main Road is a frame house built in the Vernacular Federal Style. It was constructed prior to 1800. (Montville Historical Society.)

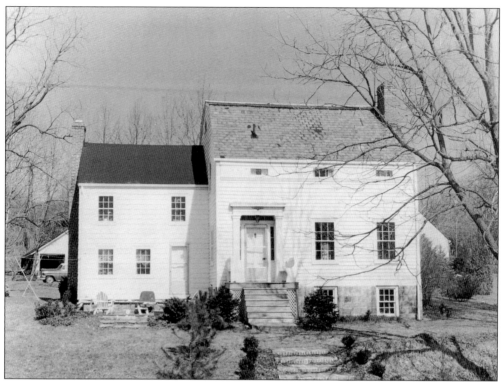

The structures shown on the following pages are homes and outbuildings that once formed part of the historic Van Duyne and Baldwin tan-yard complex. This is the Elijah Baldwin house at 16 Valhalla Road. (Montville Historical Society.)

This frame structure is the tannery of the Baldwin Van Duyne complex at 11 Valhalla Road. It dates from 1800. (Montville Historical Society.)

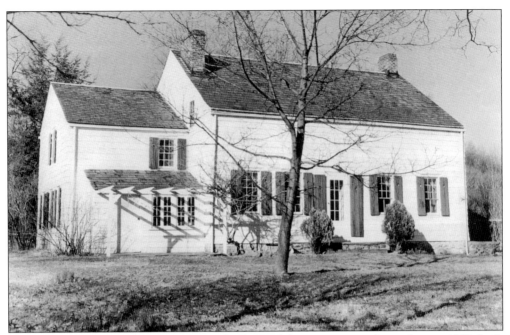

The Cornelius Van Duyne house, at 7 Valhalla Road, has a west wing dating from c. 1750, built by Cornelius Van Duyne. The main house dates from 1824 and was built by Peter Fredericks. John Unangst, a superintendent of the Morris Canal, was among the previous occupants of the house. (Montville Historical Society.)

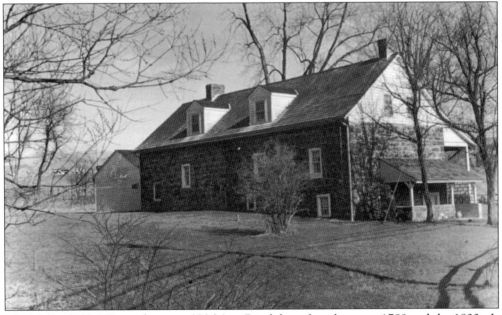

The Martin J. Van Duyne house at 292 Main Road dates from between 1789 and the 1800s. It is one of eight Dutch stone houses recognized by State and National Register Historic District listing, as nominated by the Montville Historic Preservation Review Commission. The house was the focus of a successful preservation effort, which caused the realignment of Interstate 287 to avoid its demolition. (Montville Historical Society.)

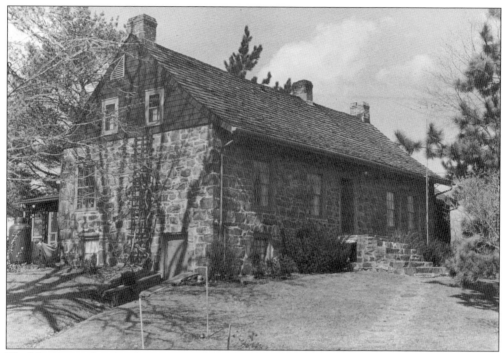

The Van Duyne-Jacobus house at 29 Changebridge Road dates from 1761 to 1778 and was once part of an 188-acre farm tract. It is another of the eight Dutch stone farmhouses successfully nominated for the State and Federal Registers. (Montville Historical Society.)

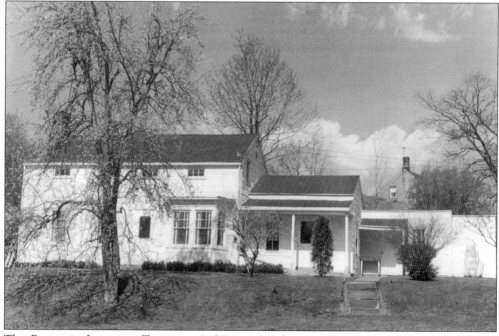

The Benjamin Lawrence Tavern at 245 Main Road is one of two taverns known to have existed in the 1770s, as its location was noted on a military map in 1779. (Montville Historical Society.)

Four

AROUND TOWACO

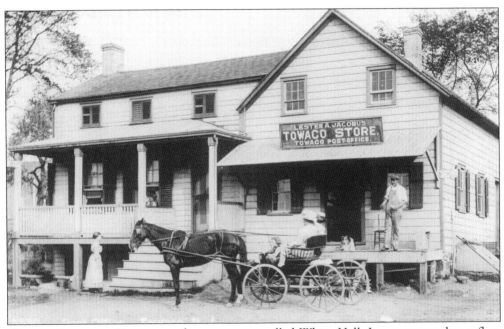

The area known as Towaco was for many years called White Hall. It was renamed to reflect the Native American heritage of the area after *TaWagh*, or hill, in 1924. The Jacobus and Van Duyne families were among the early settlers of the section. The rural nature of Towaco, which is traversed by the canal route and the railroad, remains; however, in recent years many of the farms for which the area has been known have been transformed into residential use. This chapter looks back at Towaco's earlier commercial establishments and sites, when the canal still was utilized for some commerce, and for recreation as well. One business was the store of Lester Jacobus, located in this wooden structure at Pine Brook Road, on the Morris Canal. The building included a post office and store and has been the subject of many postcards over the years. (Montville Historical Society.)

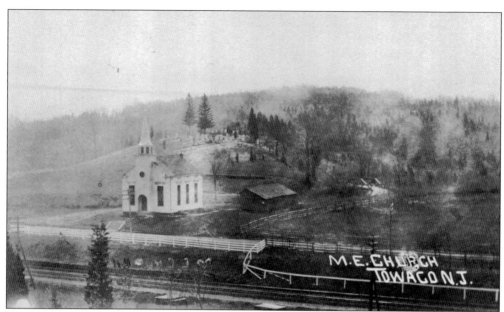

The White Hall Methodist Episcopal Church is seen to the left in this postcard view. During services, horses were tied at the shed to the right of the church. Cemetery Hill is on a rise in the distance beyond the church, a canal bridge is to the right beyond the church, and the railroad tracks are in the foreground. The church was constructed in 1859. In 1972, it combined with the Pine Brook Methodist Episcopal Church to form the Montville United Methodist Church. In later years it was replaced by a new structure. (Montville Historical Society.)

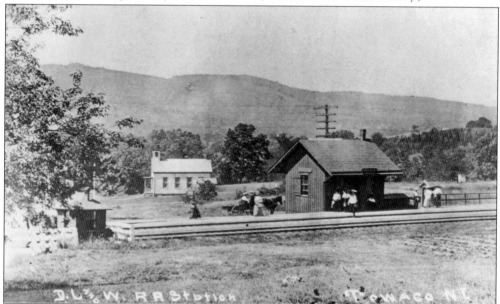

This is a view of Towaco's first railroad station and the guardhouse on Waughaw and Pine Brook Roads, which once connected across the tracks at this point. The watchman's house was manned by Walter Jacobus, grandfather of Betty Pyontek. The house had a barber's chair that was used for haircuts in the early 1900s. The Towaco schoolhouse is visible in the center of the photograph. (Courtesy of Montville Township.)

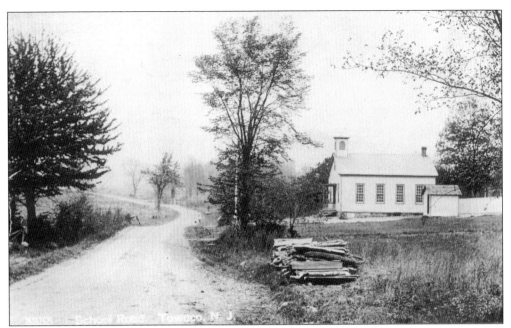

This view captures the rural setting of the Towaco School on Waughaw Road near Main Road. Later, the school building became the Lyceum Theater. Today, it is a private home, which has been moved farther back from the road. (Courtesy of Mildred Banke.)

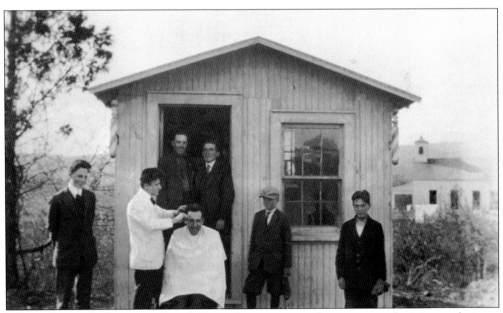

Barber Louis Gigliotti, uncle of Doris Lewis, is in the process of giving a haircut. Also present in this c. 1920 photograph are Al Hill Sr., left, Van Pentz, right, and Clarence Smith, in the doorway on the right. Smith is the great-uncle of Evelyn Kovarik. In the distance the Lyceum theater can be seen. (Courtesy of Mildred Banke.)

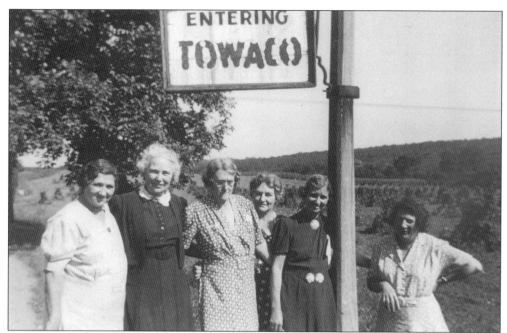

The White Hall section was officially changed to Towaco on the Fourth of July in 1904, with the Montville Band playing the "Star-Spangled Banner" and official speeches at the former red-painted, frame train station. State Senator Young, an area resident, led the effort to give the area a name reflecting the area's Native American heritage. These women, photographed under a new street sign, seem to approve of the renaming. (Montville Historical Society.)

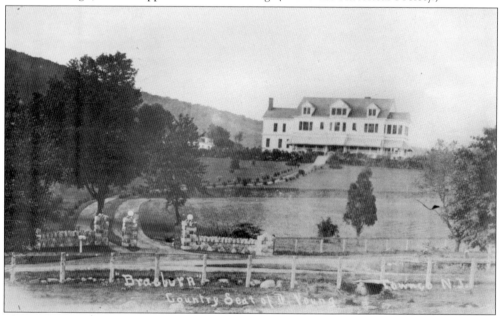

The Colonial Revival mansion on the hill above Jacksonville Road was "Braeburn," the home of Senator Young. It is said that this property had the second cement road (Jacksonville Road) in the state laid in front of it. The property was the Braeburn Nursing Home in the 1960s. (Montville Historical Society.)

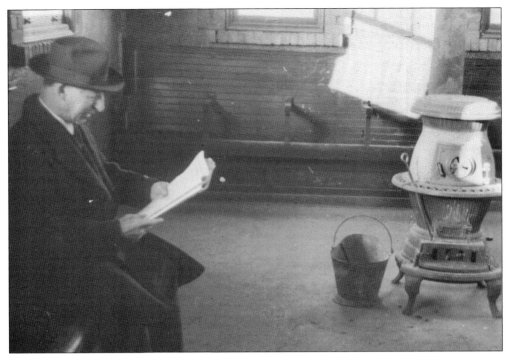

Theodore Fred Sedivec was photographed while inside the Towaco station while waiting for the train to New York during his morning commute from his house at 398 Main Road in Towaco. (Courtesy of Teddy Sedivec.)

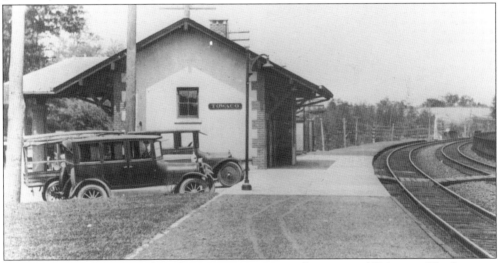

Fred Sedivec's car is parked at the Towaco station in this winter 1924 view. The line was expanded from two to four tracks after Fred Sedivec sold a section of his property to the railroad in 1924. The station was designed by railroad architect P.G. Neiss in 1912. In 1963, the old station was demolished. An eastbound shelter, built in 1925, became the prototype for a replica of the old station that was built in 2000. A dedication of a yearlong renovation, which re-created historical elements and made needed improvements, was held on June 4, 2000. New Jersey Transit and Montville Township jointly funded the project. (Montville Historical Society.)

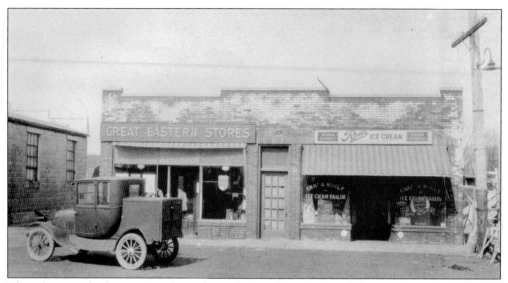

This photograph shows stores from the 1920s in the vicinity of the Towaco Station. Great Eastern stores is to the left, and Reid's Chat A While Ice-Cream Parlor is to the right. (Montville Historical Society.)

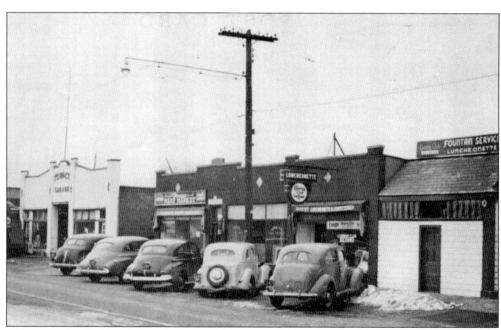

This postcard view of the Towaco Station area from the 1930s shows diagonally parked cars. At one time a post office was located in the center of this block. (Montville Historical Society.)

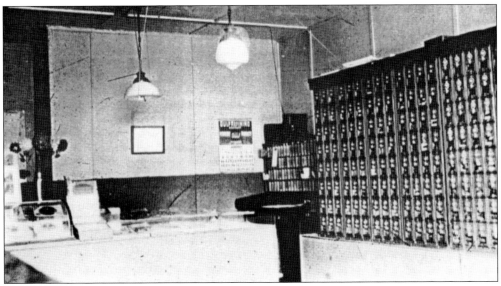

This interesting view depicts the interior of the Towaco Post Office, *c.* 1932, with the mailboxes to the right on the wall. (Courtesy of Mildred Banke.)

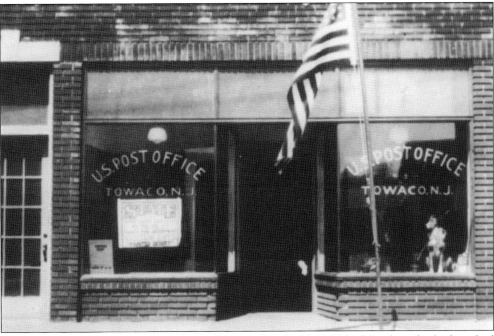

This *c.* 1932 view of the Towaco Post Office was supplied by Mildred Banke, who had worked there. Her brother Lester Jacobus was postmaster here and also at the previous location in the Lester Jacobus general store on Whitehall Road, a building that was later destroyed by fire. (Courtesy of Mildred Banke.)

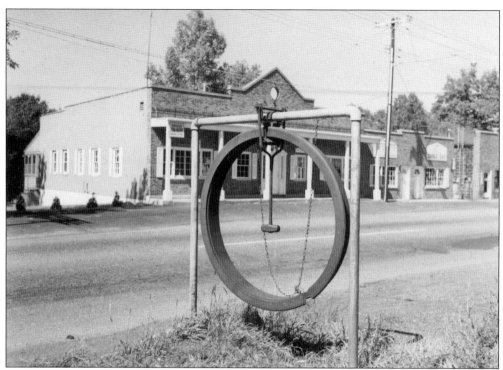

The Towaco fire ring was fashioned from a steam locomotive driving wheel "tire" and was utilized by several other fire departments as well. The wheel had to be slotted so that it could be cut off the locomotive driver. (Courtesy of Mildred Banke.)

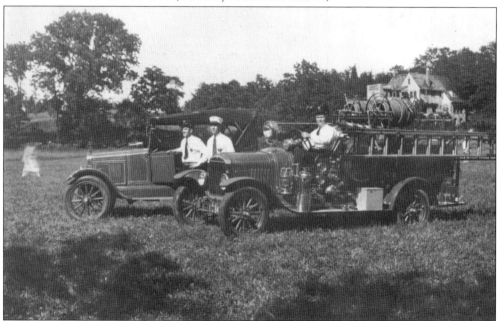

Towaco firemen and equipment are seen in this photograph from the 1920s. Shown, from left to right, are Herbie Bieswinger, Nick Gentile, and Arnold Bott Jr. (Courtesy of Mildred Banke.)

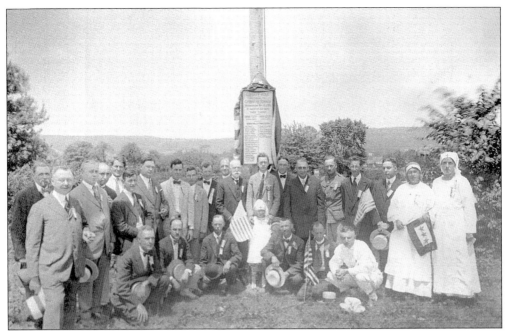

Towaco residents held a special celebration of the Fourth of July in 1918. Civil War veterans and members of the American Red Cross, the Camp Fire Girls, the Boy Scouts and area fire companies took part in the celebration. An honor plaque at the base of a flagpole was unveiled, dedicated to those who served in World War I. The plaque is now at the Montville Historical Society. (Montville Historical Society.)

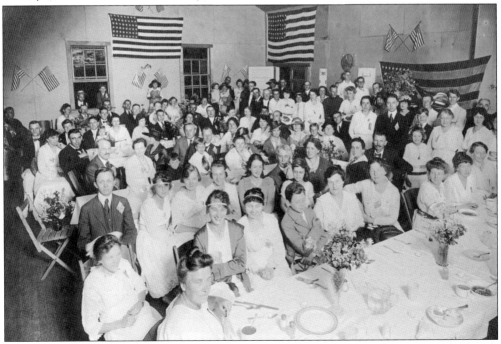

Fourth of July festival celebrants are seated at the Whitehall Methodist Episcopal Church Parish Center to enjoy tea and dessert. (Montville Historical Society.)

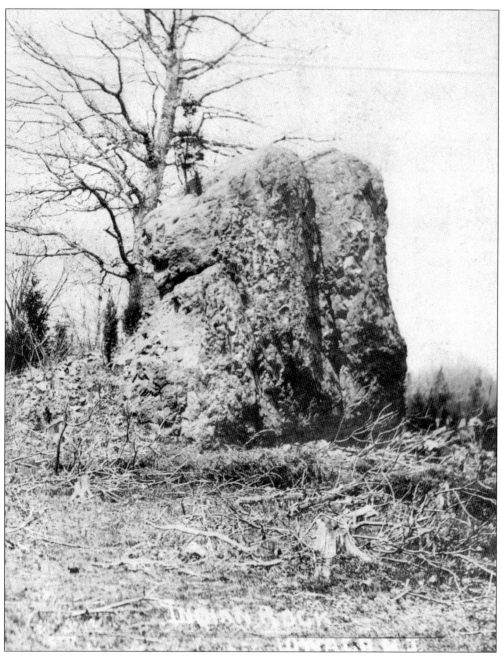

Indian Rock is seen in this view from the 1920s. The massive stone, off Pepper Road in Towaco, is believed to be the legendary meeting place and signal fire site of the Lenni Lenape tribe. (In the northernmost reaches of Montville is another noteworthy stone monument known as Tripod Rock or "Rare Roke" on historic maps. It is believed to have held significance for Stone Age dwellers. (Montville Historical Society.)

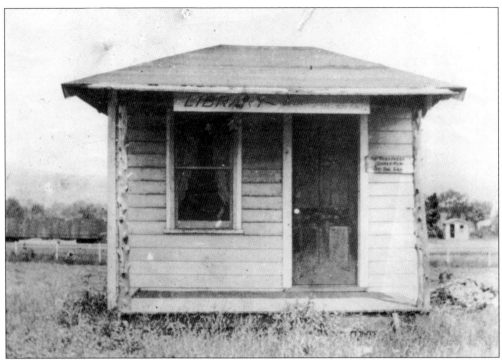

This modest shed, located on the north side of Whitehall Road, was Towaco's first library. Its hours were posted on the sign to the right of the doorway. The library was the result of the labors of Mrs. Walter Reed, who lived on Indian Hill. (Montville Historical Society.)

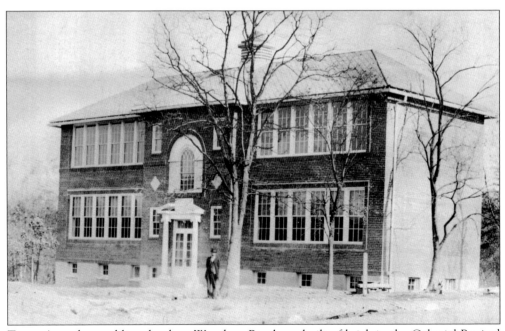

Towaco's modern public school on Waughaw Road was built of brick in the Colonial Revival style in the 1920s, as seen in this postcard view. (Montville Historical Society.)

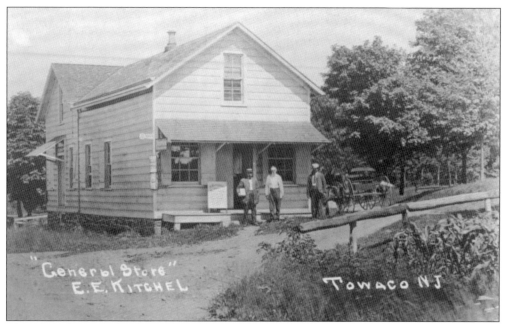

The general store of E.E. Kitchel was located on White Hall Road near the intersection of Indian Lane and opposite the railroad station. Today, the building serves as a residence. (Courtesy of Mildred Banke.)

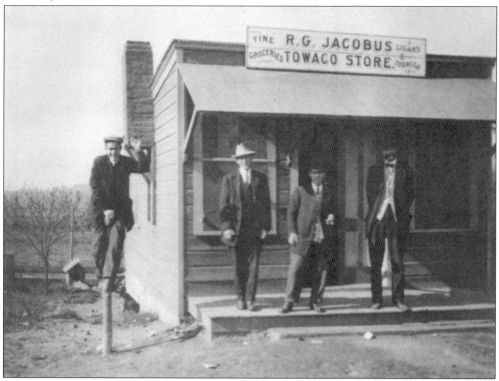

The Towaco store of R.G. Jacobus, the brother of Lester Jacobus, was located on Waughaw Road and featured fine groceries, cigars, and tobacco. (Montville Historical Society.)

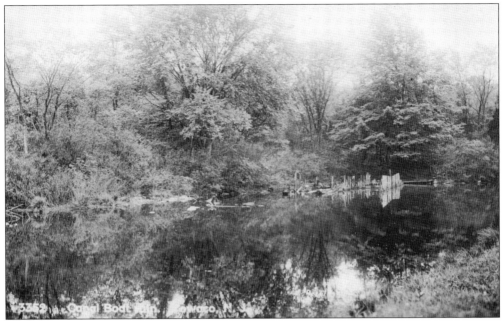

This postcard shows a turning basin of the Morris Canal at Towaco, with the remains of a discarded and deteriorating canal boat along the distant bank. The view elicits a certain wistful feeling of nostalgia for days past. (Courtesy of Evelyn J. Kovarik and Edith F. Metz.)

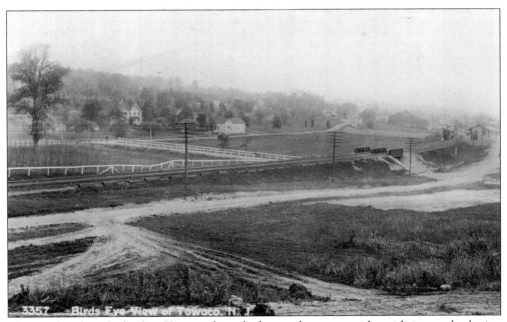

These railroad tracks lead to Towaco through the nearby countryside, with its gently sloping terrain. The under grade railroad bridge is for today's Firehouse Road. The Kitchel store can be seen directly across the tracks, with the Morris Canal behind it. (Courtesy of Evelyn J. Kovarik and Edith F. Metz.)

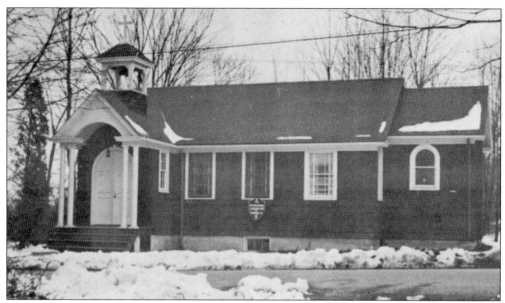

The Episcopal Church of the Transfiguration on Pine Brook Road began in 1921 as a mission. Built from a Sears and Roebuck kit, it was erected at the corner of Two Bridges and Pine Brook Roads. (Montville Historical Society.)

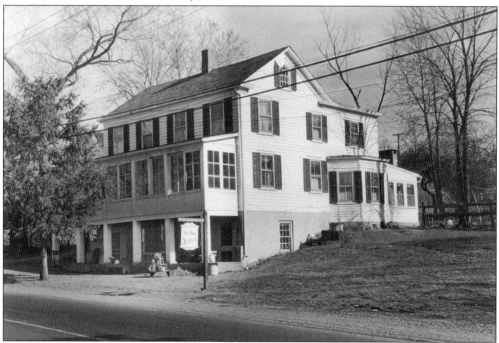

The Canal House at 855 Main Road existed prior to the 1828 advent of the Morris Canal to Towaco. The head of Plane 10 East was located to the north of the Canal House, across Main Road. The stone sleepers, which once supported the plane rails, are the only vestiges of the canal's presence near the site. The building was owned by the Morris Canal and Banking company from 1830 to 1868, after which it became a store and later a private residence. (Montville Historical Society.)

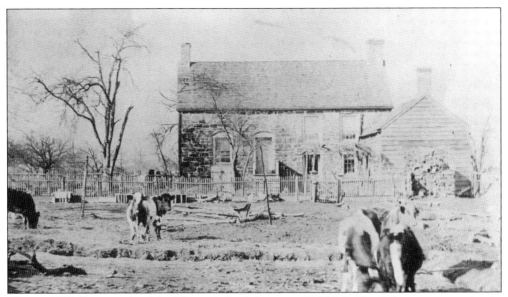

This *c.* 1896 photograph of the Henry J. Cook house at 824 Main Road shows cows grazing in the foreground. The home originally had fine stonework, but only the exterior stone walls have survived subsequent alterations. (Courtesy of Lorraine Cook.)

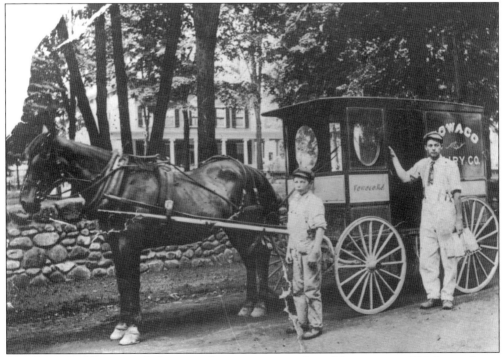

A milkman and his young helper stop for a moment on their delivery route. This horse-drawn wagon of the Towaco Dairy Company, owned by the Kayharts, was the subject of a postcard. (The Conklin Collection.)

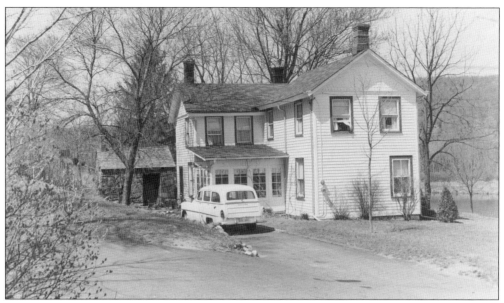

The T. Vreeland house is a pre-1853 structure with Queen Anne elements. It is located at 52 Jacksonville Road. Diagonally across the road was the Towaco Airport, featuring a single 2,200-foot sod runway, a few lean-to hangars, and a wind sock. (Montville Historical Society.)

The T. Vreeland out-kitchen is a *c.* 1790 freestanding structure at the southwest corner of the house, built to reduce the threat of fire and to keep cooking odors out of the main house. Its construction, which includes a beehive oven, is one of several structures documented by the Historic American Buildings Survey. (Montville Historical Society.)

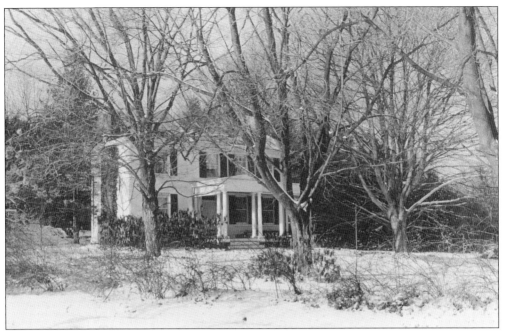

The James Van Duyne farmhouse at 32 Waughaw Road is on the National Register of Historic Places and is thought to have the oldest surviving Dutch farmhouse section, dating from 1758. It is architecturally noteworthy because each of its Victorian and Greek Revival additions, which date from *c.* 1857 and 1890, have remained unaltered. (Montville Historical Society.)

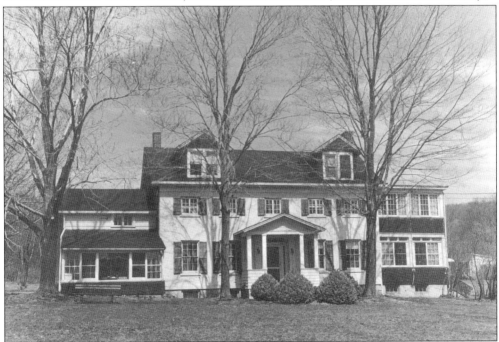

The Cornelius Jacobus house at 2 Indian Lane, on the corner of Waughaw Road, is a stone house that has been extended with Dutch-American and Greek Revival elements. Its earliest portion dates from the 1770s. (Montville Historical Society.)

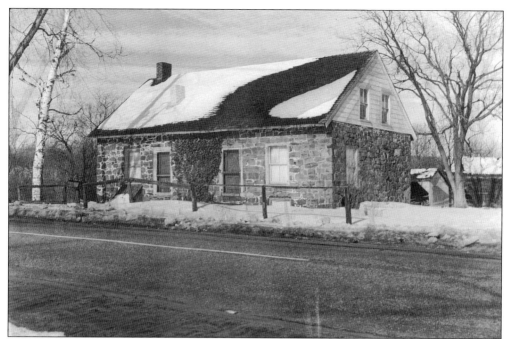

The Henry Doremus house at 490 Main Road was built prior to 1778. This structure has survived intact and has been remarkably unaltered. It has never been electrified or modernized. While staying at the home on June 25, 1780, George Washington occupied the lower room on the west end of the building (to the left in the photograph) and held a newborn infant of the union of the Doremus and Van Ness families. The house is the subject of a preservation effort headed by the Montville Historic Preservation Review Commission. (Montville Historical Society.)

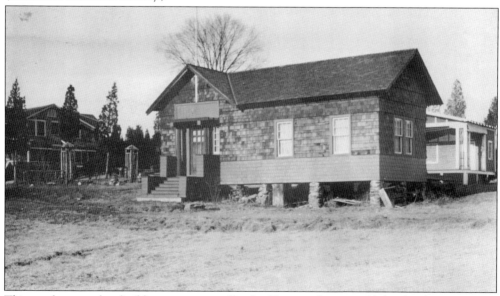

This modest wooden building was originally the Towaco Country Club, also known as the Towaco Athletic Club, which catered to a growing community. It is now a residence, and its craftsman-style exterior is unaltered. (Courtesy of Evelyn J. Kovarik and Edith F. Metz.)

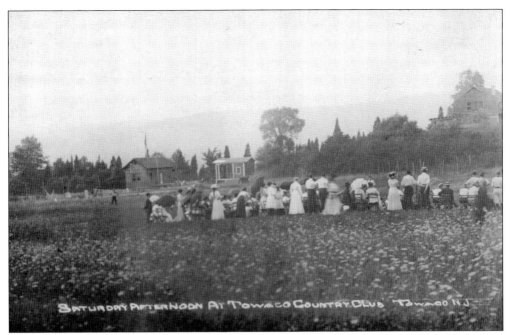

This tranquil postcard scene portrays a Saturday afternoon at the Towaco Country Club, as an assemblage of people gathers in a wildflower meadow (now Reilly Field) to watch a ball game. (Courtesy of Evelyn J. Kovarik and Edith F. Metz.)

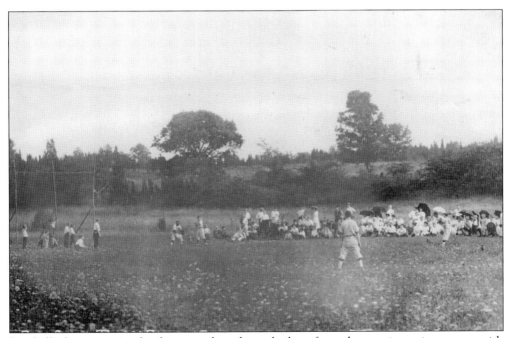

Baseball players are in the foreground as the onlookers from the previous view, many with parasols opened, are seen from the opposite side of the playing field. Today, this area is Reilly Field. (Courtesy of Evelyn J. Kovarik and Edith F. Metz.)

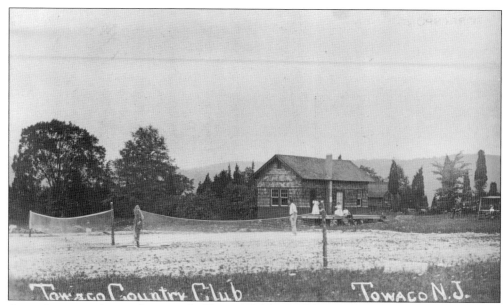

A tennis game is about to begin at the Towaco Athletic Club, as onlookers sit on the deck of the clubhouse. The clubhouse was purchased by the Episcopal diocese, which had worshiped there since August 1914. It was sold to the Towaco Women's Club in 1935. Note that there is less foliage than today, offering wider vistas. (Courtesy of Evelyn J. Kovarik and Edith F. Metz.)

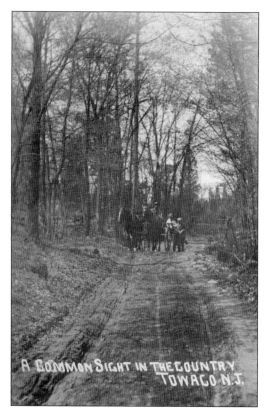

The wooded beauty of the Towaco section was captured in this postcard view of a horse and cart on an unpaved road. (Courtesy of Evelyn J. Kovarik and Edith F. Metz.)

Five

PINE BROOK

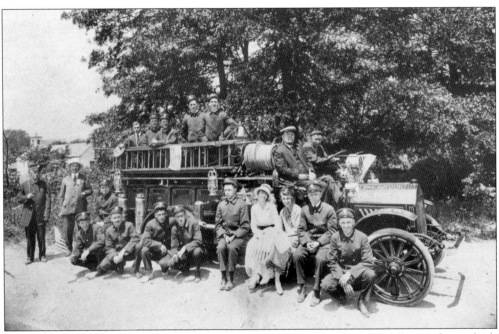

The Pine Brook section of Montville is bordered to the east by the Passaic River, along which several of Montville's oldest farms were established. The Van Duyne, Jacobus, Collerd, and Cook families trace their roots to the 18th century settlers of the area. Many of their original homesteads have survived and been recognized for their extraordinary historical value. As people became more mobile in the late 19th and early 20th century, the Pine Brook section's fresh air, country surroundings, and natural beauty made it a destination for out-of-town visitors and, in this way, a new cottage industry came into being in Pine Brook. This chapter includes scenes of some of the historic homes, places, and people from Pine Brook's past. Members of the Pine Brook Fire Department are shown during the 1918 Fourth of July Towaco celebration. (Courtesy of Steve Krobak.)

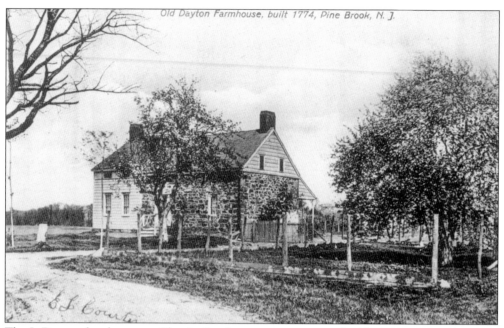

The J. Dayton farmhouse on Chapin Road is a two-story stone building constructed between 1774 and 1796. It is located on part of the William Penn tract, which he acquired in 1715. Nathaniel Young, an early New Jersey weaver, was a former occupant of the house. (Montville Historical Society.)

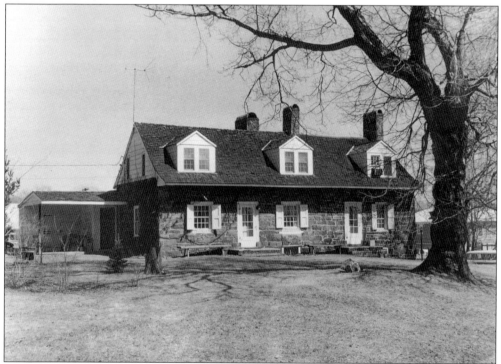

The Simon Van Duyne house at 58 Maple Avenue was built prior to 1750, with an addition dating from 1788. (Montville Historical Society.)

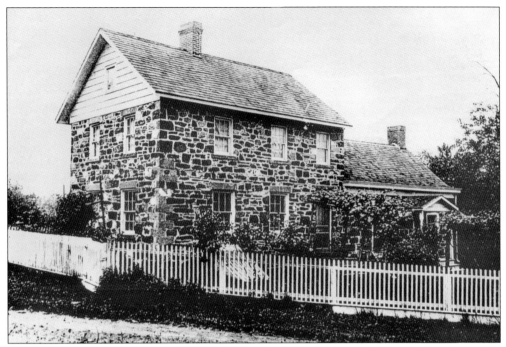

The Effingham Low house, at 102 Hook Mountain Road, is named for its first occupant, an unauthorized settler on the William Penn Tract. Effingham Low eventually settled with Richard Penn in 1775, purchasing 142 acres. (Montville Historical Society.)

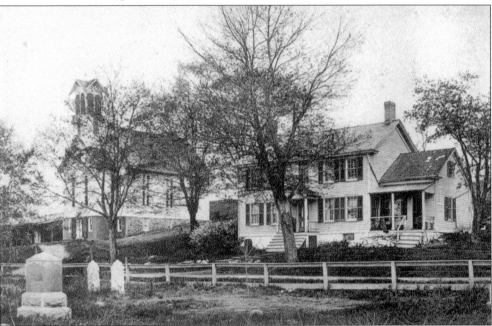

The 1843 Methodist Episcopal Church (now a restaurant) and parsonage (now demolished) are seen in this postcard view, which includes the graveyard in the foreground. In 1972, this church combined with the Whitehall Methodist Church congregation to form the Montville United Methodist Church.

Pine Brook School No. 3
Montville Twp., Morris Co., N. J.
→ 1909=10 ←

EDNA M. NULTON, Teacher

Pupils

BOYS

Hyman Horowitz	Charles Colish
Arthur Kent	David Atherly
David Schneider	Benjiman Malovany
Mahlon Tompkins	Hamlet Offhouse
Lewis Konner	Kevah Konner
Harry Schneider	Peter Bogdanski
Barnet Bader	Johnson Kent
Joseph Szymanski	Isidor Bader
Ernest Smith	Edward VanDuyne
Robert Speer	Howard Kessler
George Malovany	Wilford Collerd
Clarence Tompkins	George Conklin
Morris Bader	Peter Szymanski
George Rudinsky	Michael Zucker

GIRLS

Marion Collerd		Clara Konner
Mabel VanDuyne		Estella Levendoski
Agnes Szymanski		Lena Schneider
Hannah Malovany		Josephine Levendoski
Estella Bogdanski		Yetta Colish
Pauline Zucker		Ida Zucker
Ora VanDuyne		Dora Schneider
Anna Mayerczak	Inez Pier	Rose Colish

SCHOOL BOARD

Fred VanDuyne, Dist. Clk.	John VanRiper
Willard Apgar, Pres.	Asa T. Cook
Mr. Cole, Vice Pres.	John E. Collerd
Richard C. Kessler	Elias Vreeland

J. Howard Hulsart, County Superintendent

This souvenir program from the Pine Brook elementary school individually listed all the students for the year 1909–1910. (Courtesy of Betsy D. Demarest.)

The front cover of the souvenir program from the Pine Brook elementary school, for the year 1909–1910, pictures Edna M. Nulton, teacher, on its cover. (Courtesy of Betsy D. Demarest.)

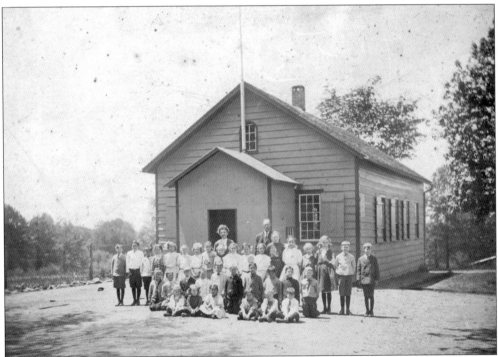

This undated group photograph shows the students and teachers of the Pine Brook two-room schoolhouse on Bloomfield Avenue and Hook Mountain Road. Pine Brook was the first section of Montville to have a schoolhouse in the 1700s. This school building was the section's third school. (Montville Historical Society.)

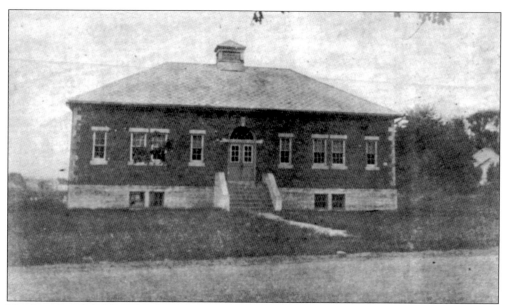

The Pine Brook public school presented a sturdy appearance in this *c.* 1924 postcard. (Courtesy of Linda Weisholtz.)

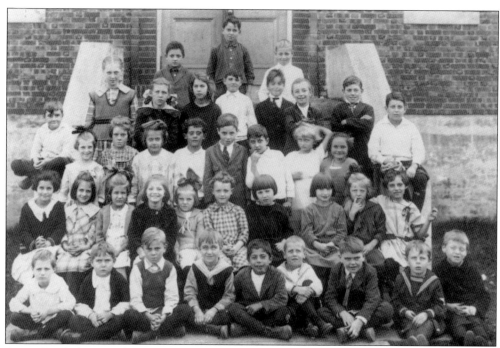

An undated photograph of Pine Book School students is part of the historical society's school pictures collection. (Montville Historical Society.)

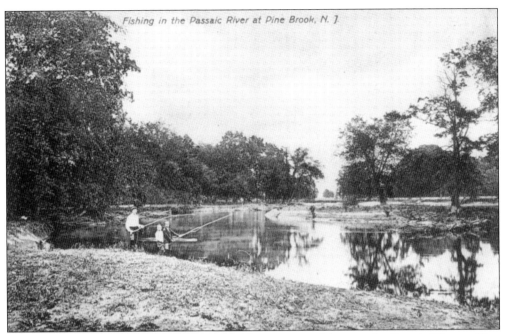

This postcard captures a tranquil time, as children are seen fishing in the Passaic River at Pine Brook. (Montville Historical Society.)

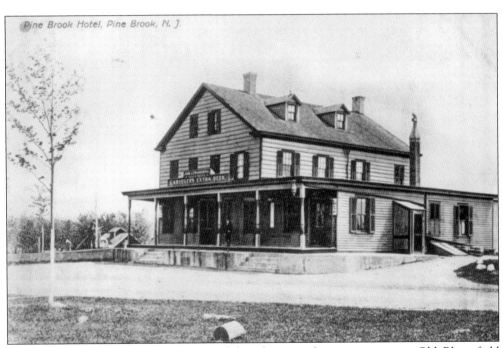

The Pine Brook Hotel offered room and board in a utilitarian setting on Old Bloomfield Avenue. It is exemplary of the modest start that the "farmhouse hotels" had in the early 1900s. The core of the building still stands as Frederick's Inn on Route 46. (Montville Historical Society.)

The Sunrise Mountain House was the Konner family's first hotel at Pine Brook. Its formidable heights inspired the family to provide motor service up the hill. The hotel was later occupied by the ministry of Father Divine in the 1940s. A mechanic known as Brother Blessed Thomas stayed on after Father Divine left. Eventually, it became the Hilltop Nursing Home, which later closed. (Montville Historical Society.)

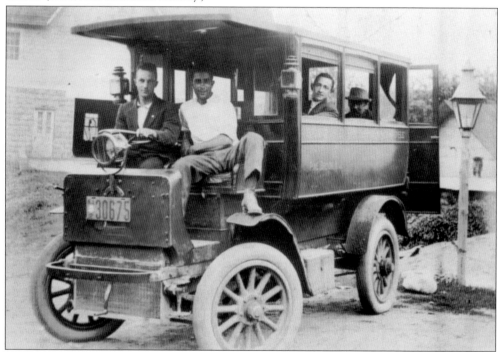

To reach the hotel, visitors traveled from Newark by trolley to Caldwell and transferred to the Konner's shuttle omnibus. In 1912, Abe Konner, at the left with his brothers Sam and Louie Konner, started the bus-taxi service running from Caldwell to Pine Brook. (Courtesy of Betsy D. Demarest.)

The Pinehurst, at 181 Pine Brook Road, was built between 1867 and 1887. This postcard view dates from *c.* 1935. The building later became the Greenbriar Residential Facility. (Courtesy of Linda Weisholtz.)

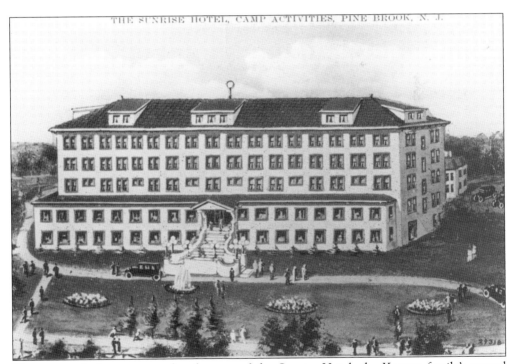

This postcard view captures the elegance of the Sunrise Hotel, the Konner family's second and most elaborate hotel. The early days of the farm hotels were recalled in Henrietta Konner Waxberg's monograph "Looking Back . . . to the Sunrise." (Montville Historical Society.)

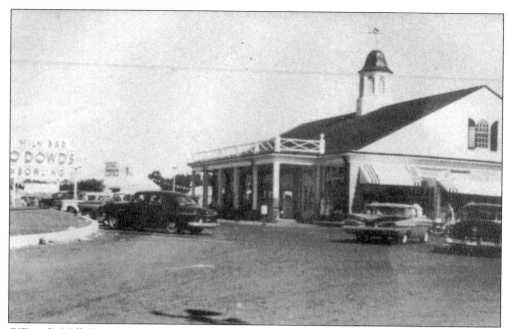

O'Dowd's Milk Bar and adjacent bowling pavilion were well-loved attractions on Route 46 at Pine Brook during the era from 1940 to 1960. (Courtesy of O'Dowd's.)

This vintage postcard illustrates the vast Pine Brook Auction Market, a permanent country fair located on Route 46 next to O'Dowd's Milk Bar. (Courtesy of Linda Weisholtz.)

Six

A Look Back at Farm Life

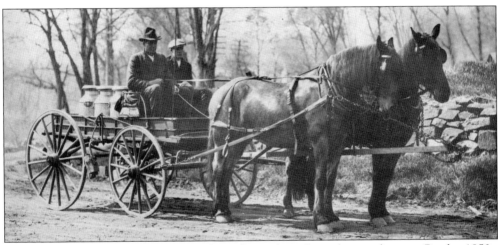

Montville's farming heritage dates back to the earliest days of its settlement. By the 1850s, Montville's agricultural economy had expanded and the sections of Pine Brook and White Hall developed more distinct town centers of their own. John L. Kanouse, writing in Munsell's *History of Morris County* in 1882, stated that Montville has "in proportion to its area . . . more tillable land than either Boonton or Pequannock.." Crop rotation was practiced, and apple and peach orchards planted, using wells and streams for irrigation. The growing of plants and flowers came into prominence, as well. Montville also had dairy farms, notably O'Dowd's of Pine Brook. Montville's earliest buildings, the Dutch stone farmhouses, are recognized for their historical value, and their continued survival serves to remind residents and visitors of Montville's long agrarian history. Even today, more than 60 barns and major farm outbuildings remain as testimony to Montville's agricultural heritage. This chapter illustrates aspects of farm life from past days in Montville. In this photograph, members of the Van Duyne family are riding down the road in a horse cart with milk containers. (Montville Historical Society.)

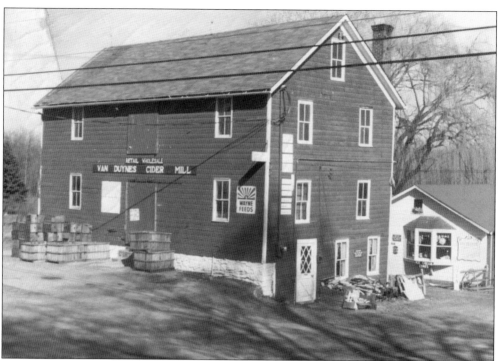

Van Duyne's Cider Mill, founded by J.W. Van Duyne, continues to function as a cider mill today. The red barn on Pine brook Road dates from 1894 (Courtesy of Doris Heddy.)

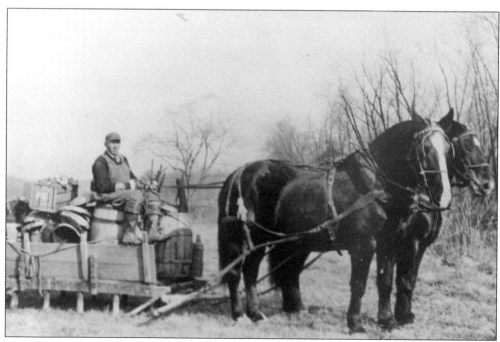

Weldon Van Duyne, whose property was beyond the cider mill, is seen in a field with plow horses.

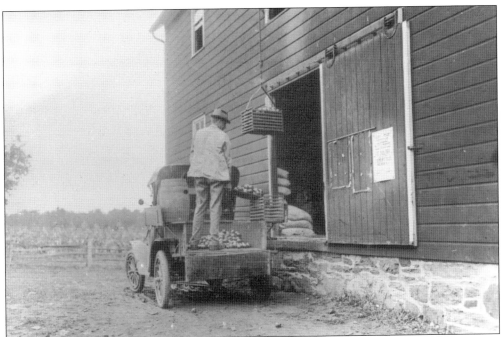

Wooden basket-crates are being filled with apples by the man standing on the truck in this 1919 photograph of the Van Duyne farm. The crates are being hoisted up to a second-story opening in the building to be put into the grinder at the third-floor level. Many families brought their own home-grown apples to be pressed into cider, traded varieties, or bartered for cider. (Courtesy of Doris Heddy.)

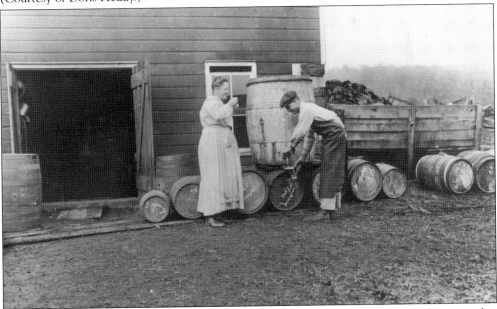

Ida Van Duyne and her son Harvey Van Duyne sample fresh apple cider from a huge wooden vat. They are the grandmother and father of the present owner of the cider mill, Doris Van Duyne Heddy. The barrels lined up on the ground under the vat bear the names of customers and the gallon quantities ordered. (Courtesy of Doris Heddy.)

Freshly tilled furrows at the Van Duyne farm await the promise of spring. This land was farmed by the family from the 1700s until the 1960s. Weldon Van Duyne was the last

farming occupant. The house remains amid a 1960s-era residential development. (Montville Historical Society.)

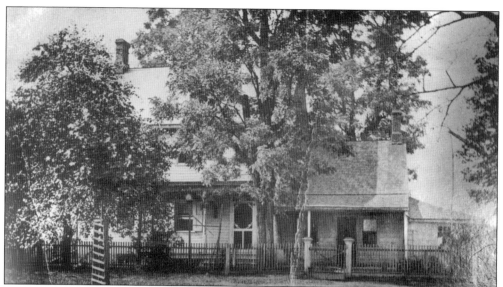

The historic farm of Al Duryea at the corner of River and Old Changebridge Roads is pictured in this postcard dated 1905. (Montville Historical Society.)

At the Duryea farm, a man is drawing water from a well using a well sweep, the counterbalanced high pole behind him. The buildings on the property were later replaced by an office complex. (Montville Historical Society.)

This farm view was taken during the Semancks' ownership in the 1960s, when it was run as a truck farm, growing cabbage, corn, peppers, and other produce. Note the surviving outbuildings: barns used for cows and horses and a wood out-kitchen to the left of the center. The farm was located on Changebridge Road, near Horseneck. (Montville Historical Society.)

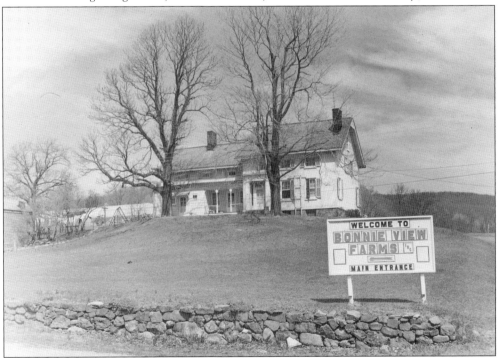

This is the entrance to Bonnie View Farms, which is no longer in the fruit-growing business but is preserved as a house. A photographic record of one of the farm's apple harvests is shared in the following pages. (Montville Historical Society.)

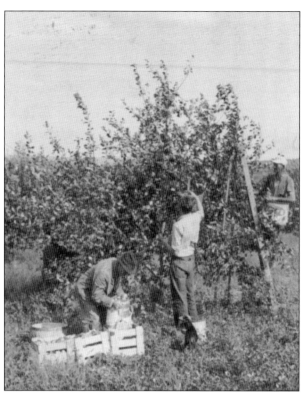

Picking fruit, from left to right, are "Chick" Curtis, Walter Mabey, J. Ward Doremus, and Munson G. Doremus. (Courtesy of Dick Vreeland.)

Ward Doremus and Walter Mabey load the crates of just-picked apples into a truck. (Courtesy of Dick Vreeland.)

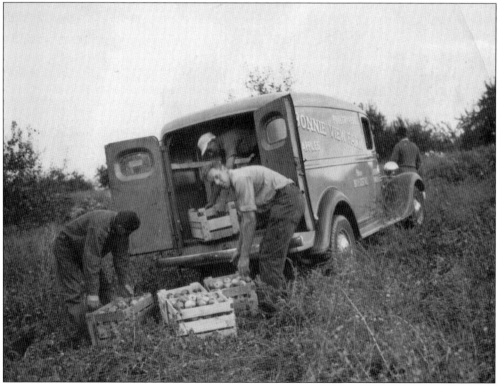

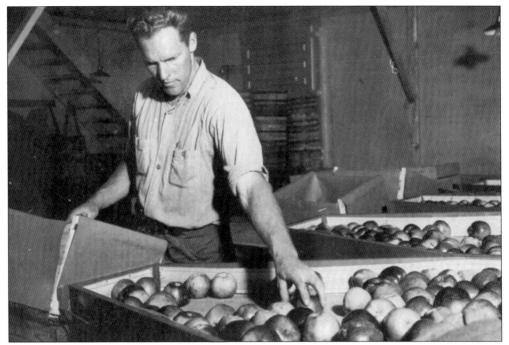

In this view, Ward Doremus is selecting apples and placing them into paper-lined wooden crates. The crates are put onto a trailer, to be transported via tractor to a storage shed. (Courtesy of Dick Vreeland.)

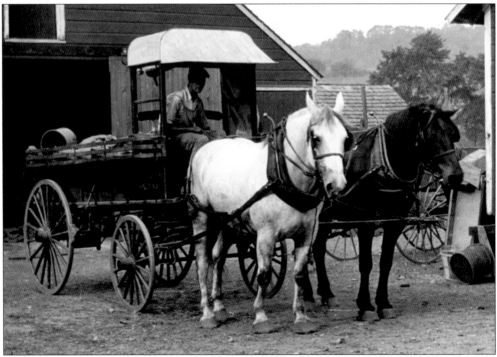

This photograph shows Fred Van Duyne's barn area, with son Halsey Van Duyne at the reins. (Montville Historical Society.)

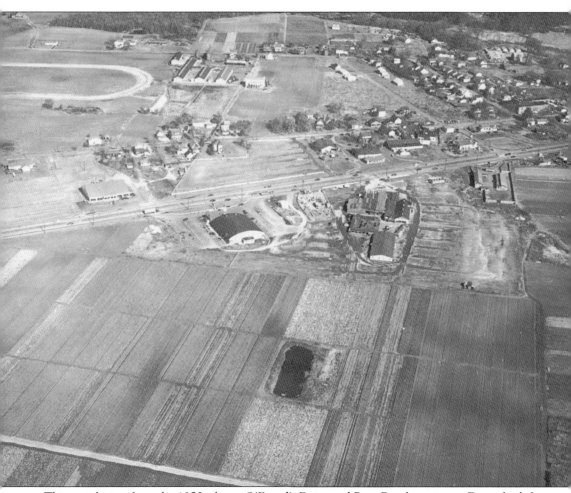

This aerial view from the 1950s shows O'Dowd's Dairy and Pine Brook environs. From the left are a racetrack for training standardbred horses, cow barns, the raw milk plant, Egger's Farm, Route 46 and the Milk Bar, cow barns that were converted for the Pine Brook Auction in 1948, the milk-bottling and ice-cream plant, additional cow barns, and the Maier Brothers' Farm in the foreground. Joseph O'Dowd, founder of O'Dowd's Dairy, was the eldest of the six children of Mary King and William O'Dowd, who in 1866 had arrived in New York from Ireland at age 22 and had found work on the farm of Dr. O'Callahan in Pine Brook. In 1879, William O'Dowd married Mary King, whose family had a neighboring 12-acre farm. By the time he was 17, Joseph O'Dowd helped his father deliver fresh produce from their then 50-acre farm to Montclair, Bloomfield, and Newark horse and wagon. He made evening runs to those cities, hauling lumber from local sawmills. Inspired by customers' requests, he acquired dairy cows, making his first milk delivery of eight quarts to Montclair on December 4, 1904. By 1925, O'Dowd's Dairy was delivering milk throughout Essex and Morris Counties. (Courtesy of the O'Dowd family.)

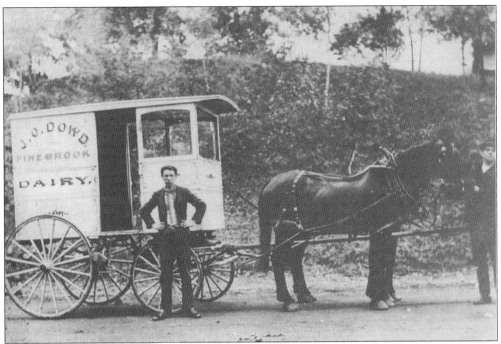

In 1905, Billy Borner, left, stands in front of the first "new" delivery wagon belonging to O'Dowd's Dairy. Joseph O'Dowd is at the far right. (Courtesy of the O'Dowd family.)

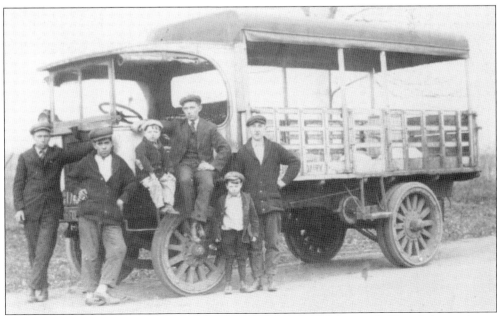

The dairy utilized a motorized truck, as shown in the c. 1915 photograph. From left to right are Dan O'Dowd, Jess Conklin, Eddie O'Dowd, Bill O'Dowd Jr., Billy O'Dowd, and Billy Borner.

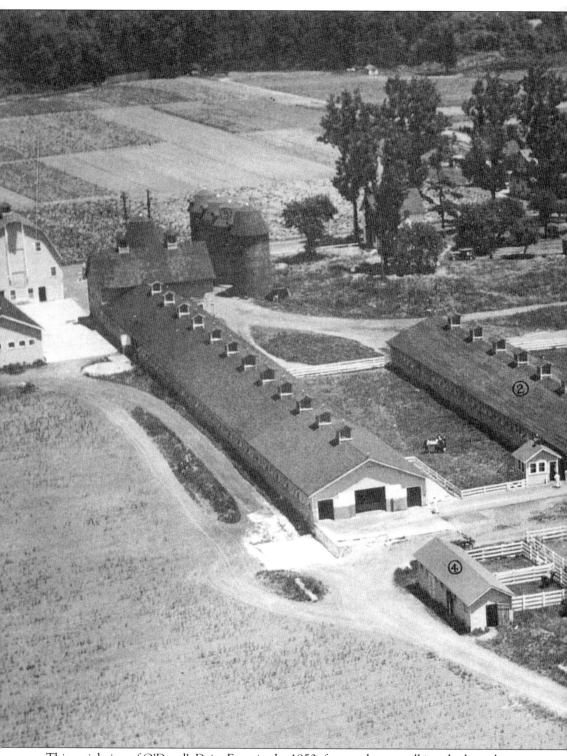

This aerial view of O'Dowd's Dairy Farm in the 1950s features barns, milking sheds, and nursery in the extensive operation. The race track and barnstormers air field was once located nearby.

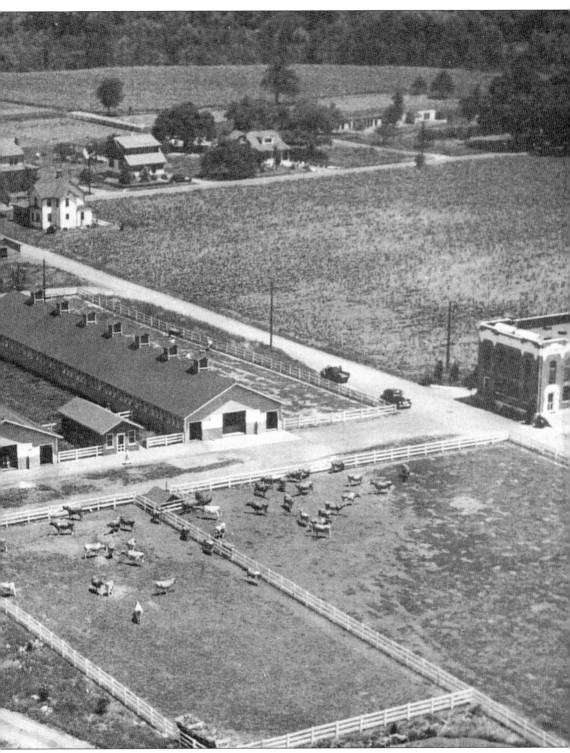

(Montville Historical Society.)

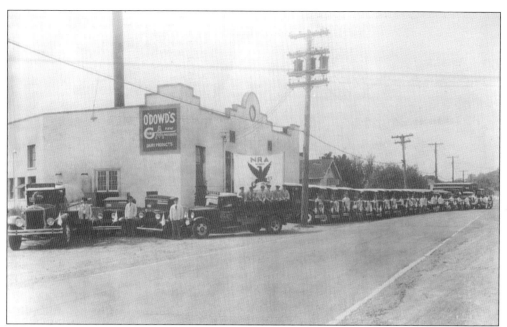

O'Dowd's motor fleet appears lined up on Bloomfield Avenue in this 1933 view. Russ Hilbert, Montville's first police chief, is at the far right. (Courtesy of the O'Dowd family.)

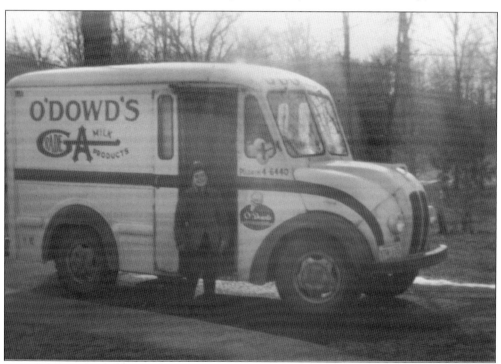

This snapshot of a milk delivery truck was provided by Jack Moran, who drove for O'Dowd's Dairy for 25 years. His son Steve Moran is pictured at the door of the truck. These Divco milk delivery trucks were notable because of their unique gear-shifting mechanism, enabling the operator to drive while standing up. (Courtesy of Frank Moran.)

In this *c.* 1930s view, part of O'Dowd's herd of Jersey and Guernsey cows were en route to the Morris County Fair. The truck was being driven by Joseph O'Dowd. (Courtesy of the O'Dowd family.)

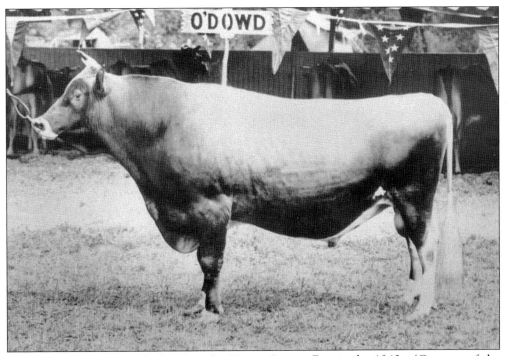

O'Dowd's prize bull was displayed at the Morris County Fair in the 1940s. (Courtesy of the O'Dowd family.)

Anna Palumbo, center, is seen with friends near the former schoolhouse on Horse Neck Road in this photograph supplied by her daughter. The schoolhouse was demolished to build a bank. (Courtesy of Susan Sampier.)

Valerie Sampier is seen feeding the cows at the Sisco farm in this 1963 view. The Sisco Farm silos and farmhouse still stand as part of the township's recreation complex. (Courtesy of Susan Sampier.)

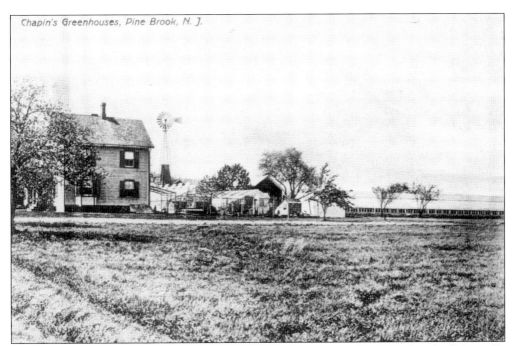

Chapin's Greenhouses, Pine Brook, N. J.

The Chapin greenhouses are seen in this view on Chapin Road in Pine Brook. (Montville Historical Society.)

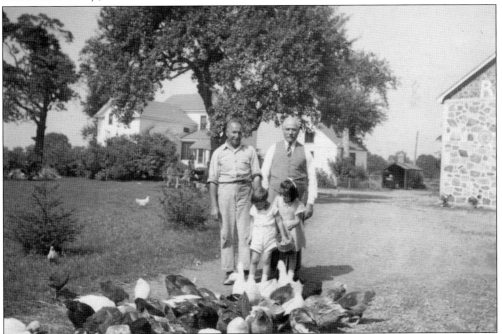

The Condorso family purchased the Dalton farm at 96 River Road, a former dairy farm, in 1928. Bartholomew Condorso and his uncle Tony are pictured here, as young members of the family feed the ducks and chickens. The distinctive stone-faced Riverview Farm barn, right, still faces west toward the Rockaway River. The photograph dates from 1959. (Courtesy of the Condorso family.)

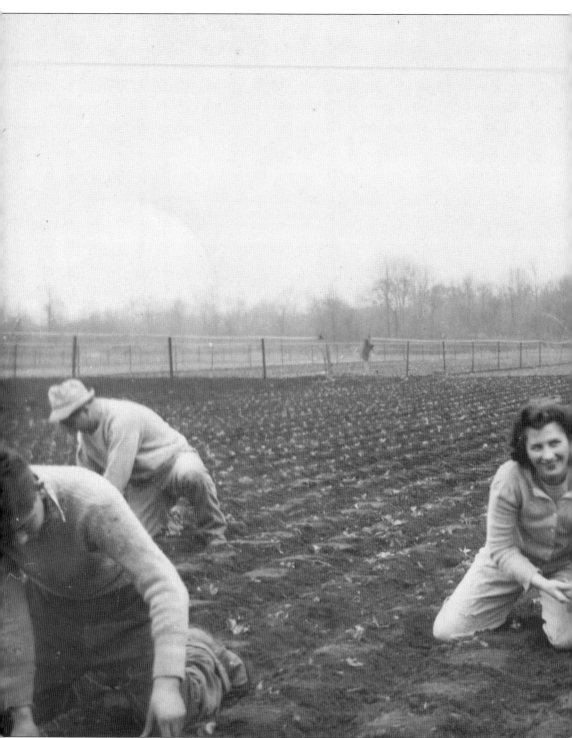

The hard work of planting seedlings is tackled by Bartholomew Condorso, his wife, Ruth Condorso, his son Anthony Condorso, and other family members. A cut-down sedan serves as a farm vehicle. In 1929, a Model T truck was purchased to transport the crops to the

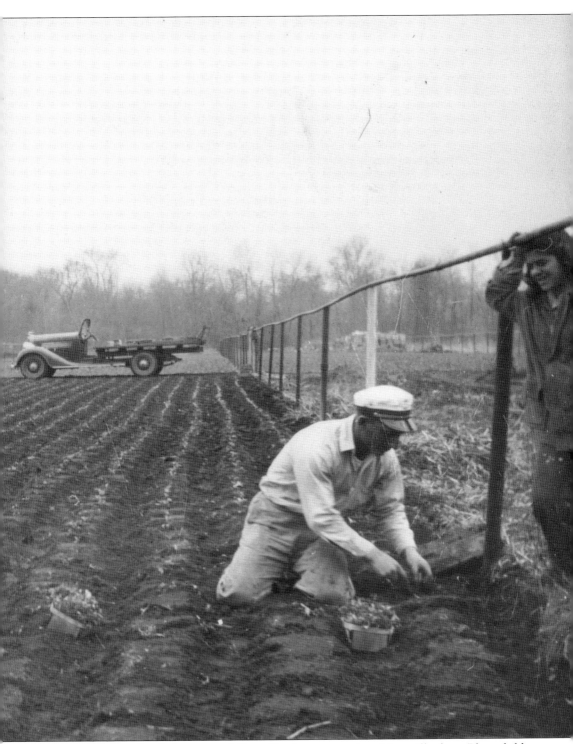

New York market. Bartholomew and Rose Condorso moved to Montville from Bloomfield, bringing crops to the Chapel Street, Newark, market by horse and wagon. (Courtesy of the Condorso family.)

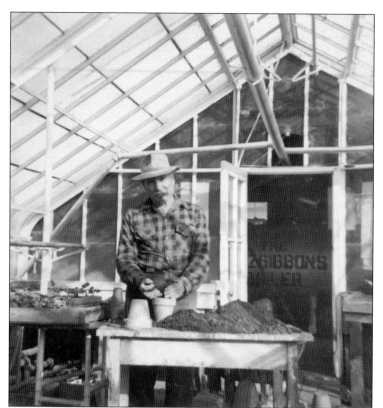

Bartholomew Condorso is seen at work filling flowerpots with soil in the farm's first greenhouse in 1950. The Condorsos raised bees and grew flowers for pollination. (Courtesy of the Condorso family.)

Rosemary Condorso, left, and a friend were pictured standing upon a massive tractor. Three wells and river water were used for irrigation. When the farm was in use as a dairy farm, the cows were brought to drink at the banks of the river. (Courtesy of the Condorso family.)

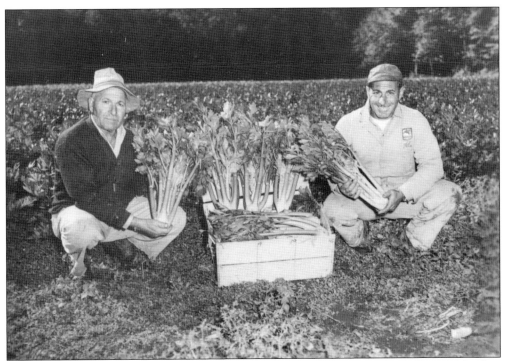

Bartholomew Condorso and his son Pat Condorso are seen holding freshly harvested celery plants, ready for market. (Courtesy of the Condorso family.)

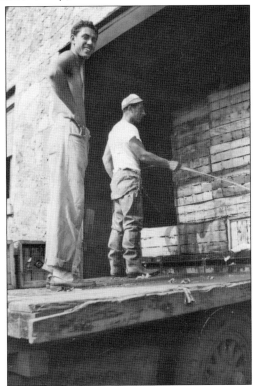

Joseph Condorso looks on as produce is washed and loaded onto a truck to be shipped to the Hunt's Point market in the Bronx. Today, the Condorso Garden Center and Farm Market continues to be a family-run operation, featuring greenhouses, annuals, shrubs, and perennials. (Courtesy of the Condorso family.)

This farm scene in Towaco depicts the beauty and serenity of an early summer season. As an increasing number of farms are sold off for development, Montville is in danger of losing its cherished open space, as well as sources of local produce. (Montville Historical Society.)

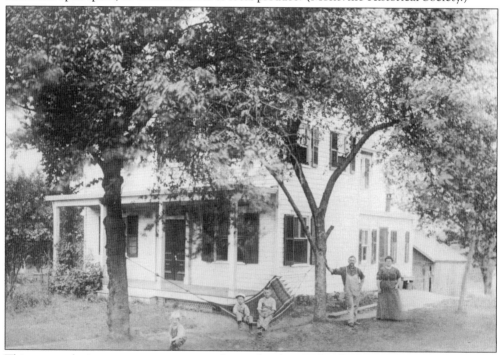

This postcard view captures a moment when a family stood still to pose for a photograph in the front yard. This is the Franklin Van Ness house on Whitehall Road, at the foot of Pine Brook Road. Mr. and Mrs. Van Ness appear with sons Oscar and Franklin Jr., in the hammock. (Courtesy of Evelyn J. Kovarik and Edith F. Metz.)

Intriguing images such as this one can transport the reader back in time. Additional memorabilia for the collection may be sent to the Montville Historical Society, P.O. Box 519, Montville, New Jersey, 07045.

Seven

MONTVILLE TOWNSHIP
PROGRESS OF 150 YEARS

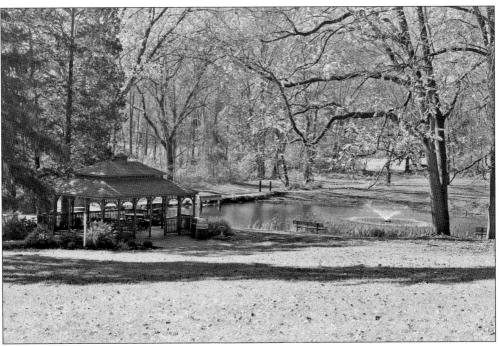

While Montville Township is 150 years old, what makes the town unique is the fact that there is strong community support to maintain its original character, as witnessed by the recent Camp Dawson gazebo project. After years of planning for the project, the Towaco Civic Association's plan came to fruition with the installation of the gazebo at Camp Dawson. To help fund the project, the association sold bricks and installed a brick path connecting the parking area to the gazebo. (Courtesy of Montville Township.)

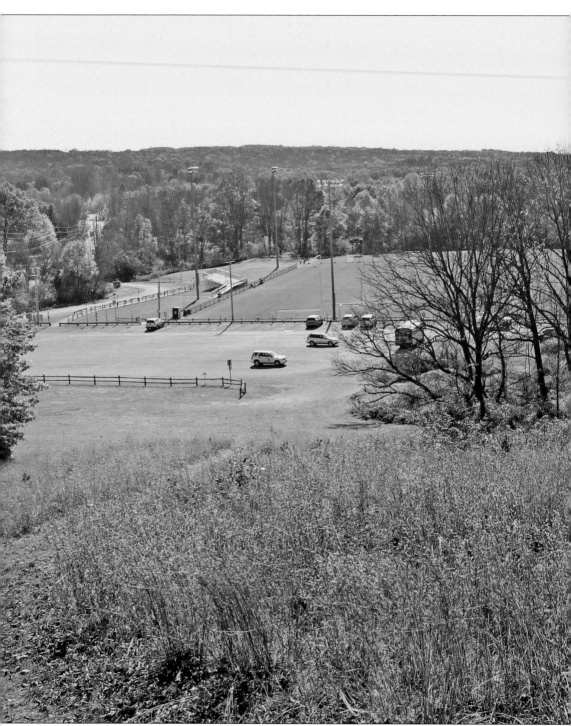

One of the attractions at Camp Dawson is Dawson Hill, a steep hill with a scenic view at the top. Montville Township has preserved more than a thousand acres of open space, including the Camp Dawson property. The Camp Dawson site is particularly critical to the township because it is within the prime area of the Towaco Valley Aquifer, which is the township's sole

ground water source. As part of his Eagle Scout project, township resident Mark Romeo created a scenic overlook that includes a sign at the top of Dawson Hill that describes the history of the aquifer and installed a bench that allows visitors to relax and enjoy the awesome view. (Courtesy of Montville Township.)

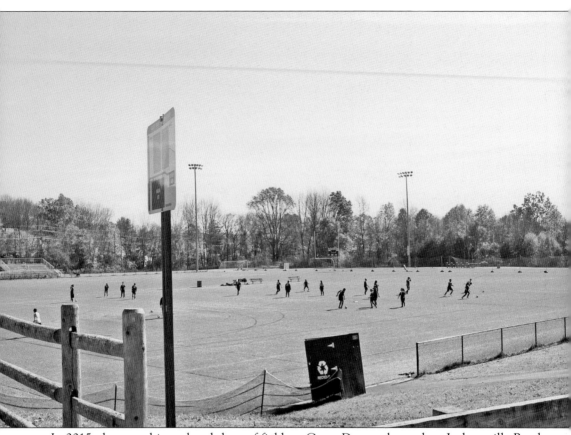

In 2015, the township replaced the turf fields at Camp Dawson located on Jacksonville Road. The fields are used primarily for field hockey, football, lacrosse, and soccer. The fields are now equipped with wireless operated lights, which has allowed for expanded use of the fields. (Courtesy of Montville Township.)

There are numerous recreational facilities available for use by Montville Township residents. The athletic fields at Community Park are used specifically for soccer, football, lacrosse, rugby, and high school games. (Courtesy of Montville Township.)

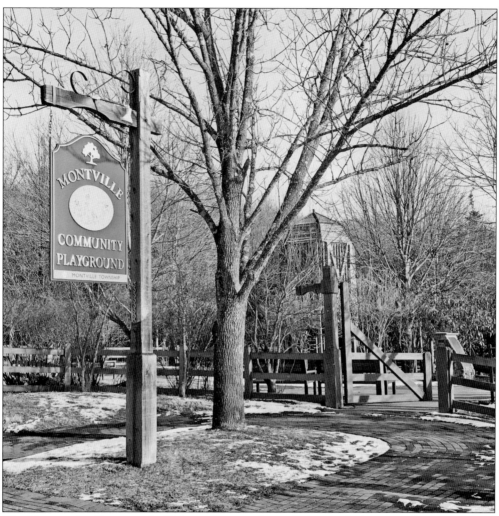

The Community Playground of Montville provides well-designed play areas for younger and older kids. The playground encompasses a beautiful farm theme and a variety of equipment for all ages. The playground is designed to recognize the township's agrarian past. (Courtesy of Montville Township.)

Residents have access to community garden plots at the Montville Community Park, located off Changebridge Road, or at the Indian Lane East organic gardens, located off Old Jacksonville Road. Families can share the experience of a strengthened community while providing fresh foods they grow for themselves. (Courtesy of Montville Township.)

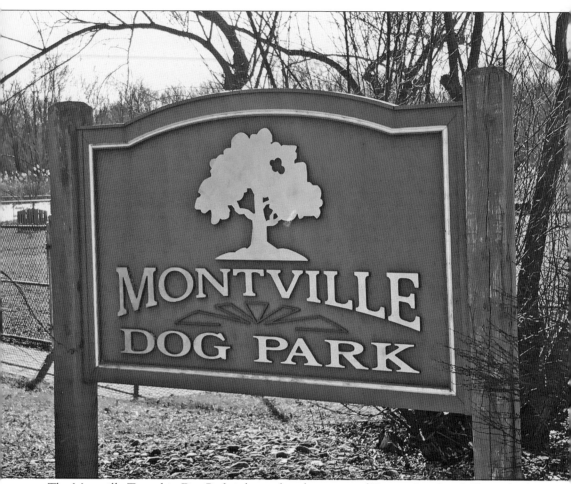

The Montville Township Dog Park is located at the corner of Kramer Road and Changebridge Road in Pine Brook. The park is approximately ¾ of an acre, with two separate fenced-in areas, one for smaller dogs and one for larger dogs. The agility equipment at the park provides an abundance of physical activity for dogs of all sizes. (Courtesy of Montville Township.)

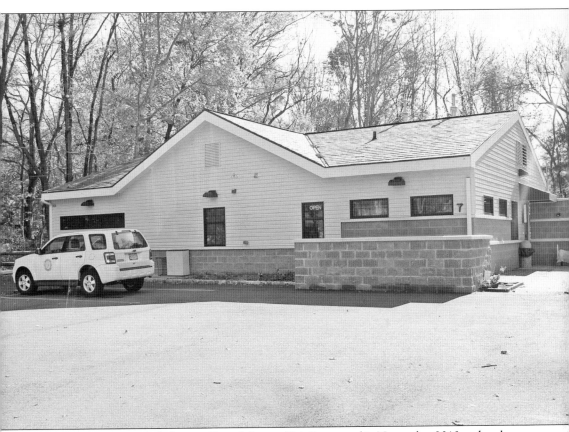

The Montville Animal Shelter on Church Lane officially opened in November 2013 and replaces the old shelter on River Road. The Montville Pet Parents, a volunteer, nonprofit organization formed in 2006 to raise funds exclusively for the shelter, was instrumental in constructing the new shelter. The animal shelter currently is utilized by several outside communities, which is a benefit to both Montville Township's taxpayers and those communities who currently utilize it. (Courtesy of Montville Township.)

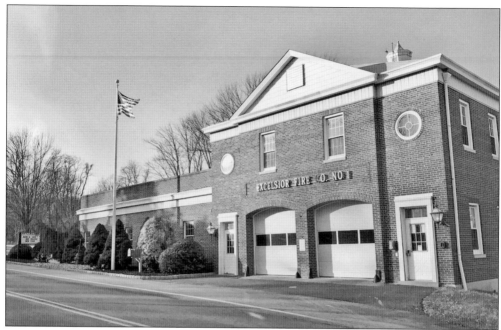

Fire District No. 1 is located in Montville. District No. 1 was organized in 1910 and for more than 100 years has been protecting the residents and businesses of Montville. The department is comprised of 100 percent volunteer members and includes the Ladies Auxiliary. (Courtesy of Montville Township.)

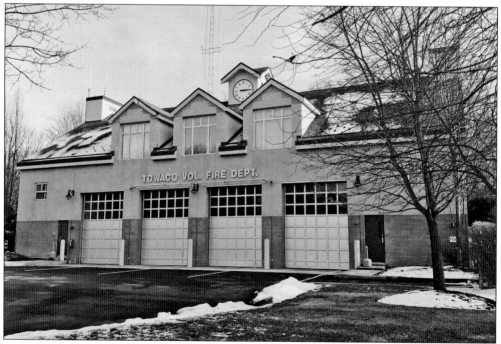

Fire District No. 2 is located in Towaco. District No. 2 was organized in 1920. The current firehouse, built in 1998, accommodates all the modern firefighting needs. The Towaco Fire District is getting ready to celebrate its 100th anniversary in 2020. (Courtesy of Montville Township.)

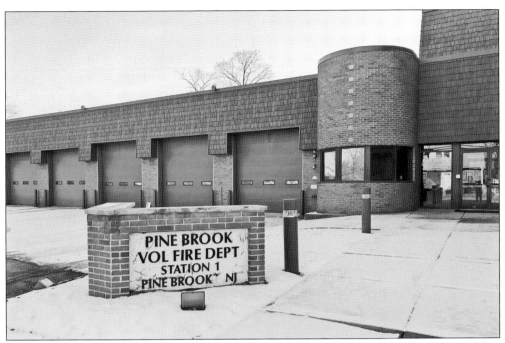

Fire District No. 3 is located in Pine Brook. District No. 3 was organized in 1913 and has been a fixture in the community for more than 100 years. The current Pine Brook Firehouse is located on the same site as the original firehouse with modernization to the site over time to accommodate today's needs. (Courtesy of Montville Township.)

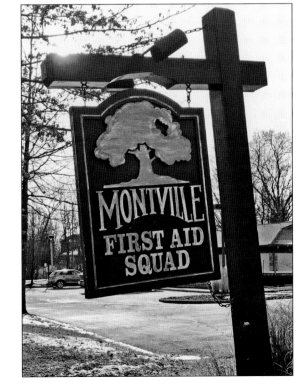

The Montville Township First Aid Squad was established in 1964 and recently celebrated its 50th anniversary in 2014. The first aid squad provides 24-hour, year-round service to the community, which includes free medical transport to Montville Township residents in need. The organization is always looking for volunteers to meet the needs of the community. (Courtesy of Montville Township.)

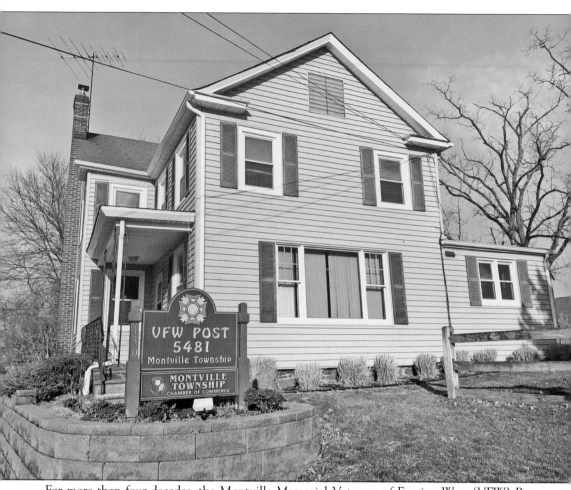

For more than four decades, the Montville Memorial Veterans of Foreign Wars (VFW) Post 5481 and its members have been a fixture in the community, reminding everyone of the sacrifices of the men and women in the armed forces. Residents who have served this country are encouraged to join the post. (Courtesy of Montville Township.)

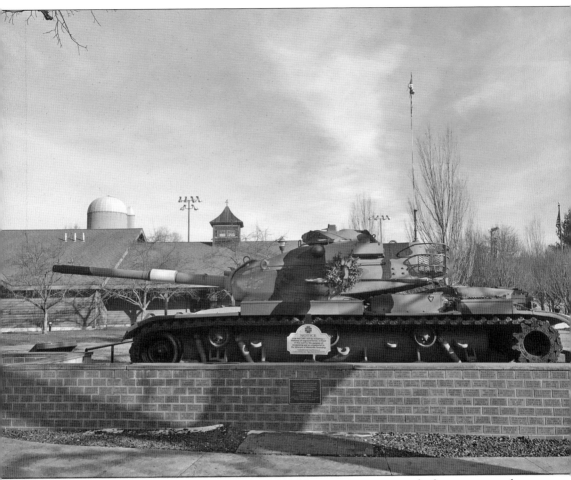

Located behind the VFW Post 5481 is the M60 Vietnam era army tank that serves as the backdrop to the post's remembrance ceremonies. The annual memorial services are led by Frank Warholic and Joseph Quade, former and current Post 5481 commanders. (Courtesy of Montville Township.)

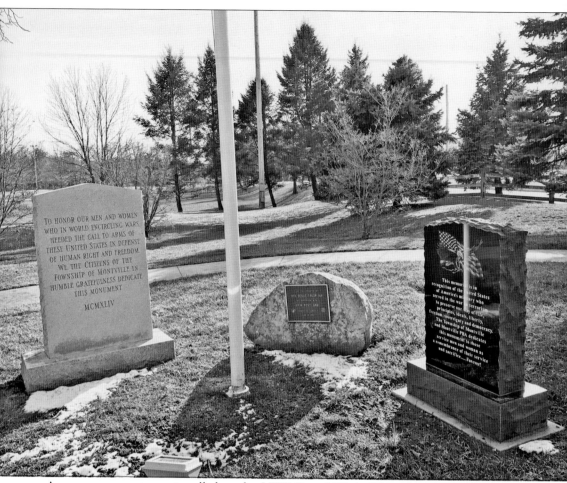

A new monument was installed at the VFW Post 5481 building during the Veterans Day ceremony in November 2016. The monument is dedicated to those veterans who served in the war on terror. Funding for the monument was provided by the Montville Township Policemen's Benevolent Association No. 140. (Courtesy of Montville Township.)

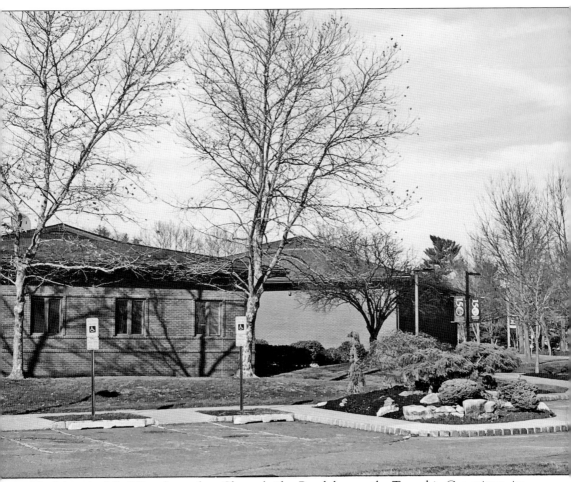

The Municipal Building, located on Changebridge Road, houses the Township Committee, its associated departments, and their employees. Built in 1994, the building is the centerpiece of Montville Township's government. In 2016, in special recognition of the 150th anniversary, the Township Committee Chambers were refurbished and rededicated at the January 1, 2017, Reorganization Meeting. (Courtesy of Montville Township.)

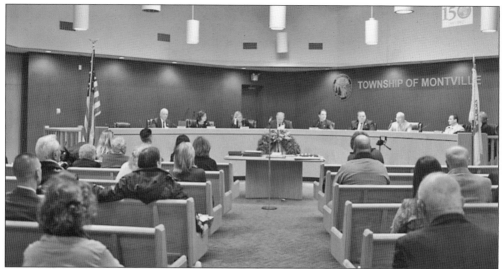

In commemoration of the 150th anniversary, the Montville Township Committee commenced the year's celebration on January 1, 2017 with updated renovations to the Municipal Council Chambers. The council chambers were originally dedicated in honor of James P. Vreeland Jr., former Montville Township mayor and New Jersey state senator, as well as grandfather to assistant township administrator June Hercek. The beautifully designed room, with new carpeting and reupholstered benches, will continue to be the centerpiece of the community's government. (Courtesy of K.J. Bence Photography.)

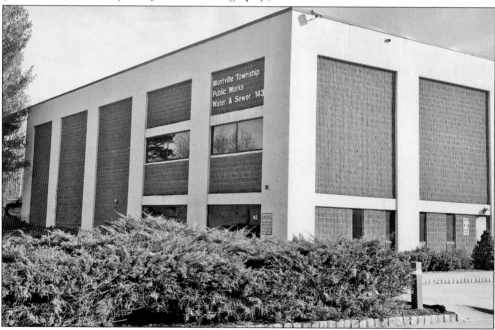

The Department of Public Works is subdivided into four divisions, all located at 143 River Road: Fleet Division, Road Division, Facilities Division, and Water and Sewer Division. In 2014, the Township provided the Board of Education with space for its maintenance division under a shared service agreement to save the taxpayers of Montville Township tax dollars. (Courtesy of Montville Township.)

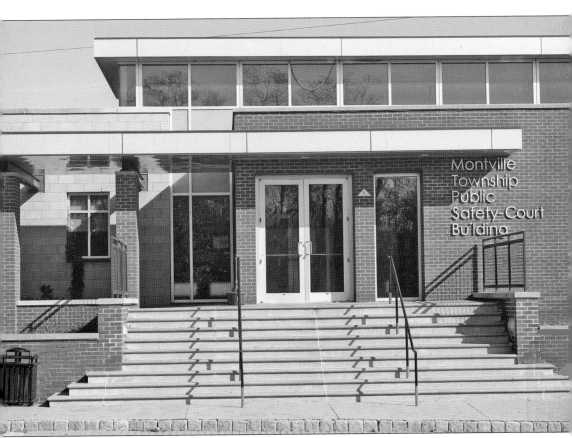

The Montville Township Police Department provides around-the-clock coverage to approximately 22,000 residents, covering 19 square miles of territory with approximately 110 miles of paved roadway. The Montville Township Municipal Court is also located within the public safety building. (Courtesy of Montville Township.)

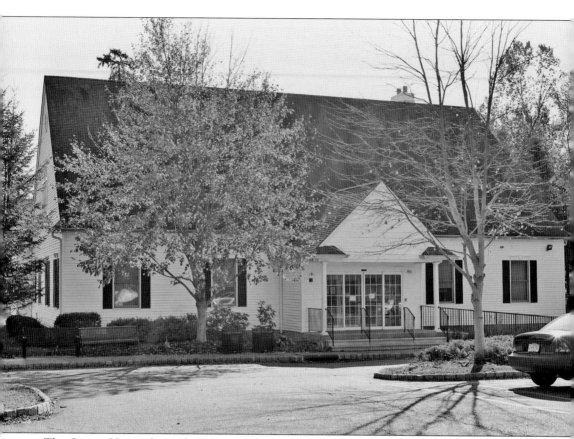

The Senior House, located on Route 202 in Montville, provides a location for a variety of social services to its residents with an emphasis on its senior citizen population. In 2016, the Senior House received a Community Development Block Grant through Morris County, which allowed for improvements that will provide our residents expanded services during emergency situations. In addition, local township organizations are permitted to utilize this facility seven days a week. (Courtesy of Montville Township.)

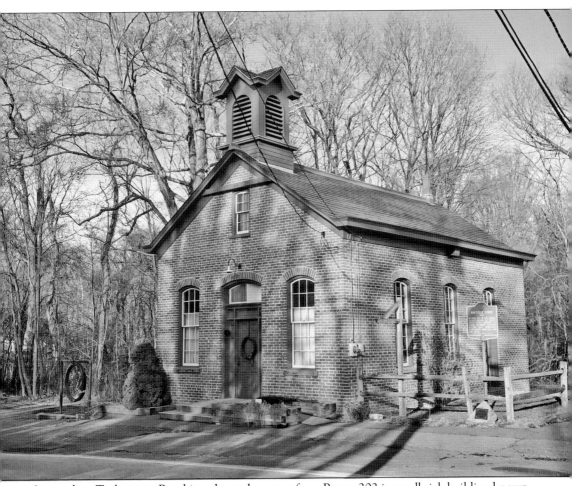

Located on Taylortown Road just down the street from Route 202 is a redbrick building known as the Montville Township Historical Museum. The museum houses a variety of historical artifacts on display. The museum once served as Montville's original schoolhouse, post office, and town hall and is a constant reminder of the simplicity of Montville. (Courtesy of Montville Township.)

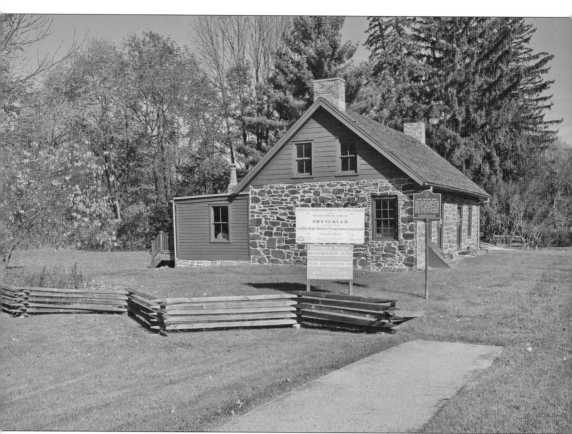

The Henry Doremus House, at 490 Main Road, was built prior to 1778. The structure has survived intact and has been remarkably unaltered. Today the Doremus House is utilized as a historical learning tool for residents and schoolchildren. Every July Fourth, the Montville Township Historical Society reads the Declaration of Independence, which highlights the rich history of America. (Courtesy of Montville Township.)

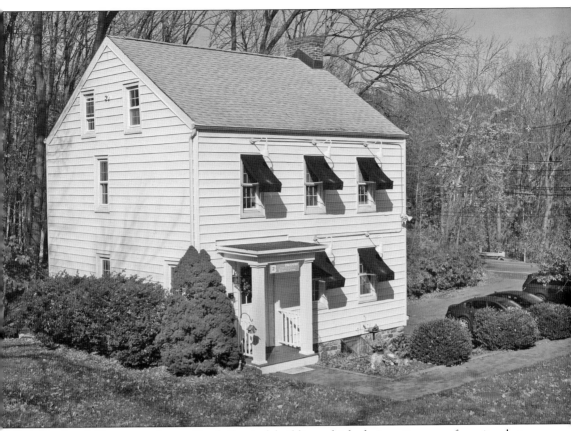

The Canal House is a frame Greek Revival building which derives its name from its close proximity to the Morris Canal. While the building has seen many uses over its lifetime, it continues to serve as both a reminder of Montville's past and present viability. The building is currently occupied by Blank2Branded, a marketing firm. (Courtesy of Montville Township.)

The Montville Township Public Library serves the communities of Montville, Pine Brook, and Towaco. In addition to the collection of books and magazines, the library contains an impressive collection of audiobooks, books on tape, books on CD, and movies. The Chinese book and newspaper collections are significant, as is the collection of both Chinese and Bollywood movies. The motto of the library is "Explore Your World," and the library provides a great deal of opportunities for the community to learn and discover. (Courtesy of Montville Township.)

Montville Township High School consistently ranks among the top high schools in New Jersey thanks to dedicated teachers, motivated students, and enthusiastic parents. In line with the school motto, "You Can't Hide From Mustang Pride." Community support is vital to the success of schools as evidenced in Montville Township. (Courtesy of Montville Township.)

The Lake Valhalla Club is a privately owned club located in the Lake Valhalla section of Montville Township. Club members have access to many recreational activities, including swimming, boating, and tennis. The Lake Valhalla Club hosted the township's 150th-anniversary kick-off event, which was a great success. (Courtesy of Montville Township.)

Town welcome signs can be seen around the township. The signs highlight the entrances to Montville Township, but more importantly, they are donated and maintained by Montville Township's business community at no cost to the taxpayers. (Courtesy of Montville Township.)

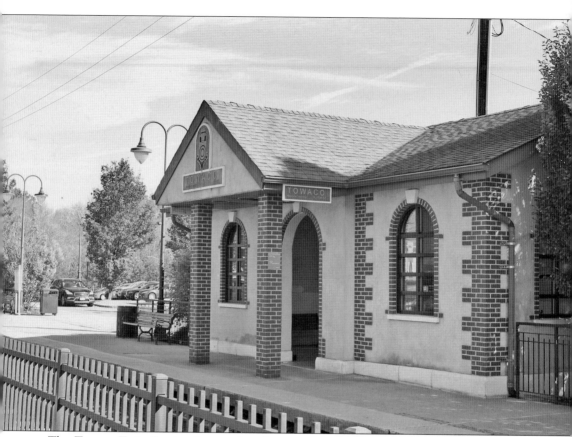

The Towaco Train Station is owned and operated by New Jersey Transit and is part of the Montville-Boonton Line. This train station provides Montville Township residents easy access to rail service for the greater metropolitan area. (Courtesy of Montville Township.)

This is one of Montville Township's many commercial, residential, and retail developments designed within the Towaco Train Station transit village. The site encourages easy access for pedestrians to shopping, living, and mass transit—all within walking distance. (Courtesy of Montville Township.)

Towaco Crossing, located on Whitehall Road adjacent to the Towaco Train Station, includes Rails Steakhouse, unique shops, and residences within the transit village. Rails Steakhouse has become the centerpiece of the Towaco transit village development concept and has been the catalyst to further similar development in this area. (Courtesy of Montville Township.)

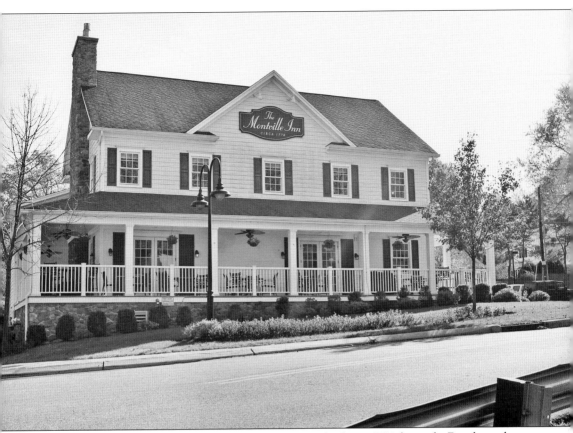

The Montville Inn, the original Mandeville Inn, was built in 1770 by early Dutch settlers. When the Mandeville Inn was destroyed by a fire in the early 1900s, it was rebuilt and named the Montville Inn. Today the restaurant provides fine dining in a relaxed atmosphere. (Courtesy of Montville Township.)

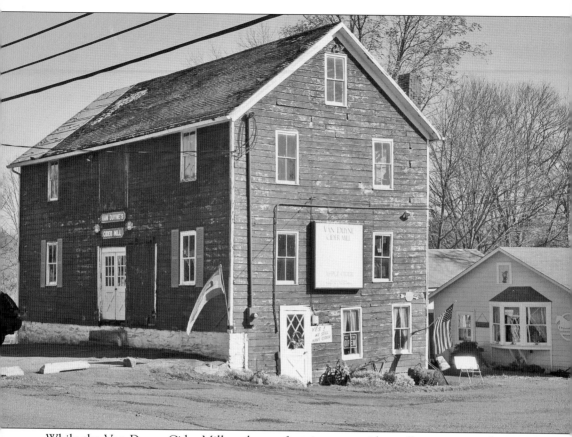

While the Van Duyne Cider Mill no longer functions as a cider mill, it remains a historical landmark in the community and a constant reminder of the township's agricultural past. The building dates back to 1894. (Courtesy of Montville Township.)

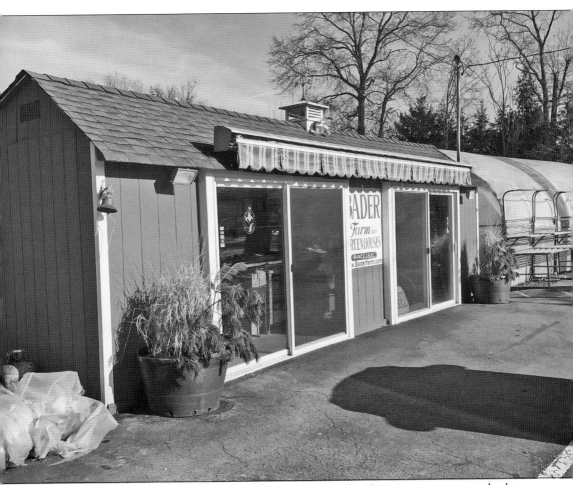

Bader Farm, located on Changebridge Road in Pine Brook, has been operating since the late 1800s. The business continues to be operated by family members, and the products from their farm are sold locally. (Courtesy of Montville Township.)

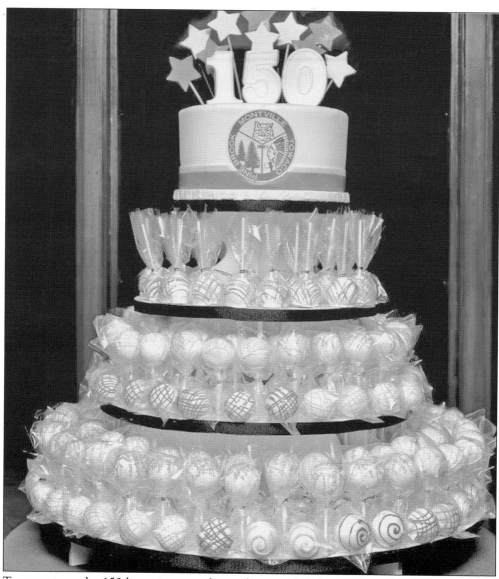

To commence the 150th anniversary, those who attended the 150th cocktail celebration on January 1, 2017, at the Lake Valhalla Club enjoyed the delicious 150th cake. The cake was baked exclusively by Suzi Cakes in Boonton, New Jersey. (Courtesy of K.J. Bence Photography.)